365 PHOTO CHALLENGES

From one-off artistic photo ideas to challenges that last for a whole year, there are 365 challenges in this book to inspire your photography. Find a challenge to suit you in the different categories and then focus your lens with the top tips and extra ideas. Be inspired by the photography on each challenge page and add the hashtags to your uploads.

6 PHOTO CATEGORIES

Extended 4 – 45
Challenge yourself to sticking to a theme from anything between a week to a whole year.

Seasonal 46 – 79
Find a photo challenge to suit the season, from festive fun to summer sun.

Portrait 80 – 119
With twists on traditional portraits, these challenges will have you creating amazing photos.

Lifestyle 120 – 213
Challenge yourself to look at every day life in a new way, from food and fashion to homes and hobbies.

Artistic 214 – 311
Use clever shooting techniques and experiment with editing to push your photography to the next level.

Landscape and Nature 312 – 368
Get outside and seek the extraordinary, from huge landscapes to the tiniest details of the natural world.

52 PHOTOS 52 WEEKS

Challenge yourself each week and tick each photo off the list. Interpret each picture in your own, unique way.

☐ 1 Selfie	☐ 14 Close-up landscape	☐ 27 Something pink	☐ 40 Flowers	
☐ 2 Architecture	☐ 15 Metallic	☐ 28 Family	☐ 41 High-level	
☐ 3 Something blue	☐ 16 Blurred	☐ 29 Changing season	☐ 42 Minimalist	
☐ 4 Patterns	☐ 17 Urban landscape	☐ 30 Headshot	☐ 43 Perfection	
☐ 5 Black and white portrait	☐ 18 The unexpected	☐ 31 Candid camera	☐ 44 Alone	
☐ 6 Natural landscape	☐ 19 Nature vs man-made	☐ 32 Water	☐ 45 View from the window	
☐ 7 Faceless portrait	☐ 20 Night-time	☐ 33 Collaboration		
☐ 8 Panoramic view	☐ 21 Fantasy	☐ 34 Food	☐ 46 Backlit portrait	
☐ 9 Shadows	☐ 22 Hands	☐ 35 Fashion	☐ 47 Abandoned	
☐ 10 Sunset	☐ 23 Weather	☐ 36 Natural habitat	☐ 48 Friendship	
☐ 11 Reflection	☐ 24 Genius at work	☐ 37 Colourful landscape	☐ 49 Dancing	
☐ 12 On the move	☐ 25 Silhouette	☐ 38 Low-level	☐ 50 Symmetry	
☐ 13 Fine detail	☐ 26 Retro	☐ 39 Handmade	☐ 51 Workspace	
			☐ 52 Selfie	

#52photos52weeks #inspiration #weekl #studio365challenge

 100 HAPPY DAYS

Take a photo every day for 100 days of something that makes you happy. It can be absolutely anything you like – if it has made you smile, photograph it.

Focus

- Complete the challenge without using filters.
- Continue the challenge for a further 100 days.
- Find a different theme for each photo – no repeats!

cupcakebaeckerin/Instagram maldivesmania/Instagram keagantakesphotos/Instagram planetfervor/Instagram

#100happydays #smile #optimism #studio365challenge

#MONDAYBLUES

You've probably spotted the different daily hashtags on Instagram®. Taking part each day is a great way to join in with the Insta community. We admit that Monday can be tough. Take a photo of your Monday and share the pain. How long until the weekend?

Focus

- Make your mundane Monday sparkle with an interesting angle or filter.
- Having an epic Monday? Take a photo!
- Feeling more positive? Tag #mondaymotivation instead.

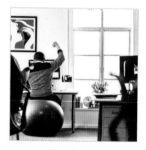

adj_brown/Instagram

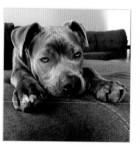

pitbullisnotacrime/Instagram

michalsleziak/Instagram

paulmurphyx/Instagram

#mondayblues #mondaymotivation #dailyphoto #studio365challenge

 #TAKEMEBACKTUESDAY

By Tuesday we're usually daydreaming about days past, whether it's the weekend just gone, or a holiday destination we'd love to return to. Get nostalgic on Tuesdays with this hashtag.

Focus

- Spread the wanderlust with destination photos.
- Share a picture from your weekend...
- ... or share a snap from years ago.

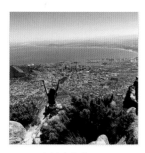

buhderka/Instagram

bzoratto2/Instagram

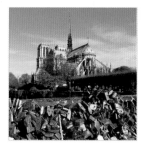

dennistinations/Instagram

mimirdz05/Instagram

#takemebacktuesday #traveltuesday #dailyphoto #studio365challenge

#WELLNESSWEDNESDAY

Hooray! You've made it to the middle of the week. Share your healthy mid-week vibes with this hashtag challenge.

Focus

- Head to the gym and tag your gym snap with #workoutwednesday
- Take up a new, healthy habit and share it each Wednesday.
- If you're feeling more wise than well, try #wisdomwednesday

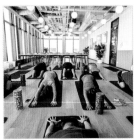

jennyschatzle/Instagram camilladallerup/Instagram wework/Instagram gahee_bartels/Instagram

#wellnesswednesday #workoutwednesday #dailyphoto #studio365challenge

#THROWBACKTHURSDAY

This classic hashtag is an opportunity to share photos from yesteryear with your followers. From the idealistic to the embarrassing, anything (really!) counts as a throwback.

Focus

- Share childhood photos.
- Reminisce about your schooldays.
- Use a photo to tell a funny story.

breathewunder/Instagram

ctcycletour/Instagram

michelleobama44/Instagram

sayegann/Instagram

#throwbackthursday #tbt #dailyphoto #studio365challenge

#FRIDAYFUNDAY

The weekend is almost here, so that's a great excuse to have some fun. Show Instagram®
how you like to have fun and share the best part of your Friday.

Focus

- Feeling fashionable? Try #fashionfriday
- Share top fun tips with your followers.
- Compose your photo in a fun way.

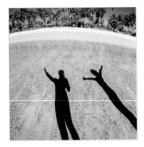

lucascher/Instagram keremmudul96/Instagram lujj89/Instagram maryostia/Instagram

#fridayfunday #fashionfriday #dailyphoto #studio365challenge

 #CATURDAY

Perhaps you haven't noticed, but the Internet is made of cats and there is, of course, a daily hashtag to celebrate our feline friends. Saturday is the day to share adorable and funny cat photos.

Focus

- Try to capture a hilarious cat photo...
- ... or take an unusual, artistic pic.
- If you're not a cat person, try #saturdayshenanigans

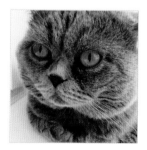
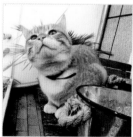

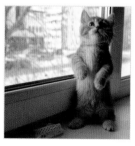

oxesmeraldaxo/Instagram

pablo_elbandido/Instagram

princess_tevy/Instagram

prettyanimalsco/Instagram

#caturday #meow #dailyphoto #studio365challenge

#SUNDAYSELFIE

Those lazy Sundays are the perfect opportunity to perfect your selfie game. Snap a few and upload the best to Instagram®.

Focus

- If you didn't have enough fun on Friday you could always use #sundayfunday
- Try out some of the selfie challenges in this book for your #sundayselfie
- Don't post the same selfie each Sunday, try something new.

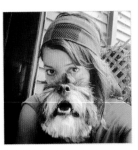
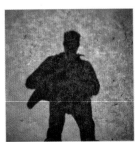
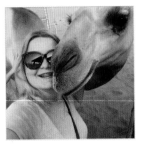

eder_villanueva_/Instagram ltlevivi/Instagram mano_deva/Instagram asjapivk/Instagram

#selfiesunday #sundayfunday #dailyphoto #studio365challenge

♥♥♥♥♡ 100 DAYS OF NATURE

Spend some time focusing on the natural world around you and post 100 shots of nature at its best in 100 days. From plants, flowers and trees, to glimpses of animals, it's time to get wild!

Focus

- Extend the challenge and document the changing seasons.
- Use your zoom and focus on the small, beautiful details.
- Venture out at sunrise or sunset for a different view.

blessing4444xx/Instagram

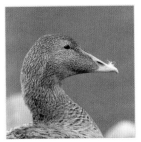
justin de villeneuve/Instagram

khaledjim65/Instagram

selena marie c/Instagram

#100daysofnature #getwild #naturelover #studio365challenge

NEW YEAR'S RESOLUTIONS

Commit to your New Year's Resolutions and resolve to share photos of your progress with your followers. Set out your resolutions and make sure to update each week.

Focus

- Be creative – don't take the same photo each week...
- ... or do take the same photo, to show the transformation!
- Try to find like-minded people online, who are trying to achieve a similar goal to you.

lisa.michelle90/Instagram

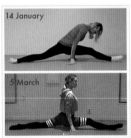

in my la la land/Instagram

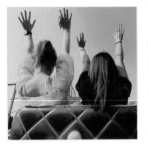

cocochanelli/Instagram

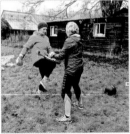

mybodyunity/Instagram

#newyearsresolution #newyearnewme #goals #studio365challenge

♥ ♥ ♥ ♥ ♡ 365 GRATEFUL

This might sound simple, but keeping it up for a whole year may be challenging! Take one photo a day that represents something you're grateful for.

Focus

- Aim to take a different type of photo each day. There are plenty of ideas in this book!
- Move between subjects on a monthly or weekly basis. From family to nature, there's plenty of inspiration.
- Alternatively, focus on something else, such as a goal you're working towards, for a whole year.

eileen.tw/Instagram

shareloveandkindness/Instagram

spinnweberin/Instagram

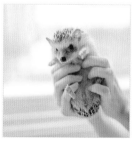
yuilllle/Instagram

#365grateful #myyearofgratitude #thankful #studio365challenge

MONTHLY MAKES

Spend a whole month making – from DIY décor to homecooked meals, share things you've made yourself with your followers. Aim to make something from scratch every day – or for extended projects, share your daily progress.

Focus

- Spend a month cooking a different cuisine each night.
- Share your latest crafty creation with your followers.
- Take up a new hobby and share your journey with your followers.

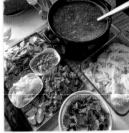

fujifilmargentina/Instagram kerryandtheboys/Instagram youka503/Instagram litefong/Instagram

#monthlymakes #homemade #DIYeveryday #studio365challenge

 A YEAR IN BOOKS

Share your reading list with your followers throughout the year. Photograph book covers, cosy reading moments and recommendations.

Focus

- Create a flat lay with your book. Coordinate objects to match the book's theme.
- Hide your book in your daily photos – make it a game for your followers to spot!
- Really get into your book and photograph locations, themes, foods or anything at all that relates to the plot.

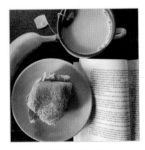
nemerise/Instagram

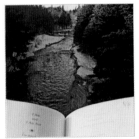
bookpimp/Instagram

booktracks/Instagram

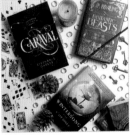
watermelanies/Instagram

#ayearinbooks #whatimreading #bibliophile #studio365challenge

A YEAR OF THANKS

Even on the most despairing of days, when everything seems to be going wrong, amidst the chaos and the noise, someone or something can always raise our spirits. Be thankful every day and share your reason; sometimes it will be hard, but it will be worth it.

Focus

- Having a great day? Then snap the reason why.
- Having a bad day? Then snap something that can turn it around.
- This 365-day challenge is a great way to nurture positivity long-term.

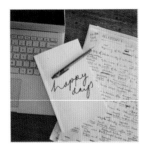
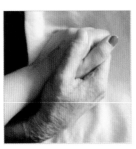

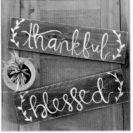

a.tale.or.two/Instagram annanonymous1/Instagram m.c.e.j/Instagram creatively_spun/Instagram

#thankful #countingmyblessings #feelingblessed #studio365challenge

 FURRY CREATURES

Brighten up your profile with a 52-week ode to our furry chums. Optional selfies and cuddles included. Snuggle up with a new pal every week and give them their virtual 15 minutes of fame.

Focus

- You may want to focus on your own pet, and make them a star...
- ... why not place them in different scenarios each week?
- Ultimate cuteness would include a whole gathering of furry buddies!

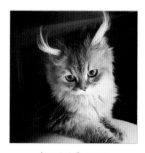
pleasantcats/Instagram

infinitelynow/Instagram

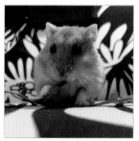
fantastic_hamsters/Instagram

envyuclothing/Instagram

#furry #fluffy #fuzzy #studio365challenge

WATCH ME GROW

This challenge will create a series of photos for you to treasure forever and is perfect for seeing how you, your children or even your pets change as time passes. Keep it up for a year, or forever!

Focus

- If you're expecting, why not watch your bump grow?
- Document your different styles and moods with a daily selfie.
- At the end of each year edit the photos into a video and see the change in less than a minute!

kellibarnettephotography/Instagram

luis le rabbit/Instagram

wan 2lavish/Instagram

jasperthegoldenboy/Instagram

#watchmegrow #bumptobaby #photoeveryday #studio365challenge

♥♥♥♡♡ # MY OBSESSION

Pick something fairly ordinary that you love photographing; from dogs waiting outside shops to colourful doors and bicycles chained to railings. Every time you see your obsession, you need to photograph it!

Focus

- Create a photo series and use your obsession to show off your skills.
- An object such as lookout binoculars and stunning views could become your "thing".
- Curate your photos using a unique hashtag.

doomanetskaya/Instagram

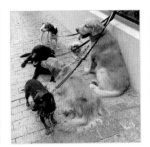

bento_do_mato/Instagram

littlebigbell/Instagram

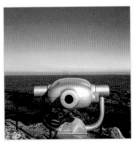

rachelabbie/Instagram

#myobsession #anothercolourfuldoor #bicycleshot #studio365challenge

52 EATS

This challenge involves a bit more than taking a photo. Write a list of 52 cuisines, pop them in a hat and draw one out each week. Cook one cuisine each week and share your creations with your followers.

Focus

- Choose countries around the world or focus on specific cuisines from one region or continent.
- Create a flat lay of your meal before you tuck in.
- It's all about presentation. Make sure the meal looks appetising before snapping a photo!

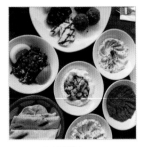

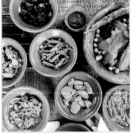

amber020491/Instagram fronybones/Instagram cedgrenbawden/Instagram rachelshao/Instagram

#52eats #weeklyfoodchallenge #eatingaroundtheworld #studio365challenge

❤❤❤♡♡ KEEP IT IN THE FAMILY

Make some memories by uploading a photo of yourself with every member of your family: from brothers and sisters to third cousins twice removed, and anyone in-between. Make it your mission to photograph everyone you're related to!

Focus

- Try to focus on any family resemblance.
- Recreate old family photos by dressing up or posing in the same way as a nostalgic snap.
- Pop all your pictures into an album – it's the perfect Christmas present for your Gran!

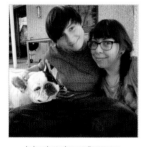
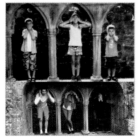
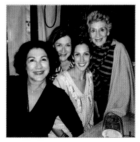
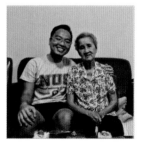

k_duweisstschonwer/Instagram saharaniamh/Instagram melissabjernigan/Instagram shermancheong77/Instagram

#keepitinthefamily #wearefamily #canyouseetheresemblance #studio365challenge

PANTONE MATCHING

Choose your favourite colour and find a pantone card or paint chip card to match. Keep the card with you at all times and whenever you see anything that matches your colour, take a photo showing the perfect match.

Focus

- Keep this up as a challenge for a whole year.
- Choose a different pantone each week.
- Pick one subject, such as vintage cars, and match every one you see to a pantone.

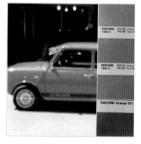

ayoubprintingpress/Instagram

ayoubprintingpress/Instagram

ayoubprintingpress/Instagram

ayoubprintingpress/Instagram

#pantonematching #perfectmatch #favouritecolour #studio365challenge

STORIES

The Story feature is a great way to update your followers on a daily basis. You can share short videos and photos — but they're only available to view for 24 hours!

Focus

- Start with a short hello in the morning and then share moments from your day.
- You could share an "obsession of the day" each day to your followers.
- If you keep it up, your followers will tune in every day for your updates!

real simple/Instagram

real simple/Instagram

real simple/Instagram

real simple/Instagram

#stories #adayinthelife #dailyupdate #studio365challenge

SEVEN AM, SEVEN PM

This challenge will quickly become a part of your daily routine. Snap a photo 12 hours apart in your day. Show your followers the start of your day, and your day as it's winding down.

Focus

- Don't snap the same selfie each time. Why not pull a funny face or take a landscape shot?
- You could share your breakfast and dinner each day.
- Stretch out the time and take a good morning and good night snap.

vv luv eat/Instagram emilydeborah/Instagram holahuan25/Instagram sleibo22/Instagram

#sevenam #sevenpm #twelvehours #studio365challenge

WANDERLUST

Make your fans green with wanderlust and share snaps from your travels and holidays. Whether you're travelling for a year or even exploring your local area, take photos that make people want to visit that location.

Focus

- Capture the sense of a place by looking for small details in the wider urban or natural landscape.
- This challenge is perfect for longer travels as you can update your followers on where you are...
- ... but can also be fun for when you're home. Aim to share a photo a week showing the amazing places near you.

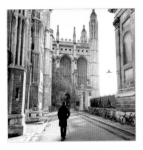
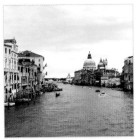
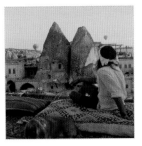

lovegreatbritain/Instagram katrina.adinda/Instagram soapynutsabout/Instagram ulyssapp/Instagram

#wanderlust #adventure #travelgoals #studio365challenge

SEASONAL LANDMARKS

Capture the amazing local landmarks throughout the seasons to inspire your followers. Choose 10 landmarks and aim to capture a photo of each landmark in each season, in all types of weather.

Focus

- Choose a mix of landmarks but make sure you can get to each of them fairly easily.
- If you live somewhere iconic, choose the most famous landmarks to photograph.
- Go out when each season is in full swing and vary the time of day you take your photos.

j.lynn.q/Instagram

jannelford/Instagram

rodchaseart/Instagram

nkolisnyk/Instagram

#seasonallandmark #summerstatue #autumnalarchitecture #studio365challenge

♥ ♥ ♥ ♥ ♡

EVERY HOUR

Choose one day a week to complete this for a whole year. Set an hourly alarm on your phone. Whenever the alarm goes off you must take a photo of what's in front of you.

Focus

- Give yourself a time limit to set up the shot and snap away.
- You could share this challenge via Stories. Your followers will look forward to it each week.
- Don't use a filter for an extra challenge. Show life as it is!

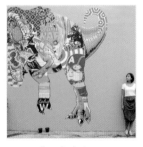

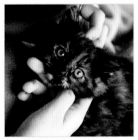

aliyaamitra/Instagram teresaallenmartinphotos/Instagram diyasssssss /Instagram fuchi_l/Instagram

#everyhour #whatamilookingat #hourlyphoto #studio365challenge

MOON WATCH

The moon changes so much from day to day, season to season and location to location. Every night turn your camera skywards and capture the moon – even on cloudy nights keep up the moon watch.

Focus

- Set up your camera for night photography. For clear moon shots you'll need a lens.
- Travel for dramatic moon shots. Capture the moon above a range of landscapes.
- Check for moon events such as eclipses and super moons and plan the shots you'll get.

aneks_/Instagram

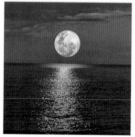
thesunthemoonthephotographer/Instagram

cazadoresdeluz/Instagram

nathbphotography/Instagram

#moonwatch #iseethemoon #andthemoonseesme #studio365challenge

I SPY...

Spend a year looking for hidden details and secret moments. You don't have to post every day but each time you spot something hiding away, take an #ispy photo!

Focus

- Look for animals hiding in trees or bushes. You'll have to be stealthy to capture their photo!
- As the seasons change, look for those first, hidden signs of the new season.
- If something out of the ordinary made you look twice, look again through your lens!

inge6688/Instagram

haveyouseenpusheen/Instagram

kiasillai/Instagram

sixsensesresidencescourchevel/Instagram

#ispy #hideandseek #iseeyou #studio365challenge

BEGINS WITH...

Spend a month(ish) and work through the alphabet in order, photographing something that begins with each letter every day. On day 1 seek out something beginning with A, all the way to something beginning with Z on day 26.

Focus

- Challenge yourself further and aim to photograph all 26 things within a theme.
- Undertake the challenge during a certain period of time: the run up to your birthday, Christmas or summer, for example.
- Keep your photos interesting and shoot close-ups, long shots, from above, from below...

annastasis/Instagram

one_lucky_mama/Instagram

francos_corner/Instagram

hgp_photography/Instagram

#beginswitha #beginswithz #photoalphabet #studio365challenge

 WEEKEND PURSUIT

Whether you're using your weekend to achieve something important, or using it for some well-deserved rest, share a photo that sums up your weekend, every weekend!

Focus

- Take photos all weekend, then on Sunday night spend some time selecting the ones you want to share.
- If you're working on something all weekend, share photos of your progress as a story.
- Limit yourself to a single photo. Just one, for the whole weekend!

pepperthechichi/Instagram

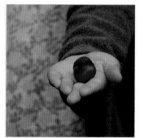
pale.blue.iris/Instagram

m_234_b/Instagram

pathandpaw/Instagram

#weekendpursuit #whatididthisweekend #livingfortheweekend #studio365challenge

ON THIS DAY

Delve into your own history or the history of the world and share a photo that celebrates or notes what happened on this day in the past, for a whole month.

Focus

- Many social media platforms allow you to look back to years past – share an old post each day to give your followers a snapshot of your past life!
- Look for historical events and reflect on them with a photo each day.
- Tie in to big historical events, such as the 50th or 100th anniversary.

thehistoryguy/Instagram

auroraserena/Instagram

darensammy88/Instagram

jddusmc/Instagram

#onthisday #yearsago #onthisdayinhistory #studio365challenge

♥♥♥♥♡ LUNCH BREAK

Get out on your break from work and explore the local area through your camera lens. Aim to share a photo for every day you're at work for a whole year.

Focus

- Join (or start) a lunchtime club and share photos from your new hobby.
- Go for a walk and look for the little details you walk past every day.
- Share the love with your colleagues and socialise with some selfies!

racheledurham_/Instagram

yanastryeltsova/Instagram

sofiadiaspires/Instagram

sutrahr/Instagram

#lunchbreak #takeabreak #working9to5 #studio365challenge

9 ON THE 9TH

On the 9th of every month share your nine favourite photos from the last month as a collage. Try to curate photos on a theme or a colour scheme.

Focus

- You could share nine of your most 'liked' photos again...
- ... or share nine photos that you didn't upload but still want to share.
- Keep an aesthetic running throughout the year for your #9onthe9th post.

ashantiomkar/Instagram

thebusythistle/Instagram

thered_72/Instagram

osummery/Instagram

#9onthe9th #favouritephotos #lastmonth #studio365challenge

 # 7 PHOTOS BEFORE 7AM

Once a month set your alarm early and head out for a photoshoot. Your aim is to capture seven photos before the clock strikes 7am.

Focus

- Keep this up throughout the year to get changes in season and weather.
- Head to the same area each time to document the change throughout the year...
- ... or get up really early and head to a beauty spot.

l.gojcaj/Instagram

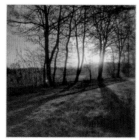

sabinew65/Instagram

oktavian_tp19/Instagram

bia96a/Instagram

#sevenbeforeseven #earlymorning #sevenphotos #studio365challenge

GROWING UP

This challenge will go on for months, depending on your age. Trawl through your family photo albums and share one photo each week representing each year of your life.

Focus

- Choose photos with a story attached and share your milestones with your followers.
- Share a photo from every birthday and time it so the challenge ends on your next birthday.
- Treat this challenge as a photographical autobiography.

abhi_abir/Instagram amyjohanna14/Instagram arjunbhardwaj04/Instagram fuaterbey/Instagram

#growingup #oneyeareachweek #mystory #studio365challenge

DAILY WALKER

❤❤♡♡♡

Try to make time every day for a walk and head out into your surroundings for fresh air and a health boost. That's 365 opportunities for your very own #walkstagram hall of fame.

Focus

- Use your walk as an out-and-about selfie opportunity.
- Aim to capture something new each time, even if your route is the same.
- Don't forget to include your companions!

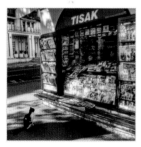
ilbaneli/Instagram

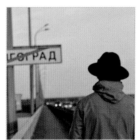
lenska /Instagram

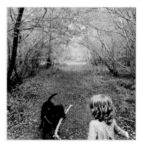
picsandthat83/Instagram

rock_glam_princess/Instagram

#walk #stroll #walking #studio365challenge

THAT'S THE ONE

We're all strutting around, snap-happy, all day long. Some images may make our feed, many will not, but which shot epitomises your day?

Focus

- It's about choosing the one shot that totally sums up your favourite activity of the day.
- It doesn't necessarily have to be your best, but your favourite.
- Choose an image that gives your fans a little insight into your life.

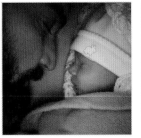

therealbonfi24/Instagram fabokagi/Instagram telemundo/Instagram allflashz06/Instagram

#photooftheday #photoofthenight #instadaily #studio365challenge

 MONTHLY THEME

Dedicate your photo feed to a monthly theme. You can interpret the theme any way you wish, and make sure to take a range of photos; from portraits and landscapes to artistic shots and even experimental!

January Fresh start
February Love
March New life

April Candid
May Happiness
June Healthy

July Travel
August Emotion
September ... Nature

October Favourite
November Thankful
December Festive

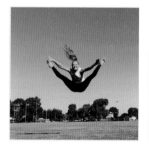
teagan_rybka/Instagram

ingwar.dovgoteles/Instagram

pleasure.of.creation/Instagram

h.y.l.m/Instagram

#monthlytheme #thoughtsonatheme #january #studio365challenge

WEAR YOUR WARDROBE

Ever stood in front of your closet in and said "I have nothing to wear"? Spend a month putting together new outfits and wearing forgotten pieces from your wardrobe, and snapping your outfits each day.

Focus

- By photographing your outfit each day you're motivating yourself to stick to a good habit of loving the clothes you already have.
- Pull out the clothes you always wear and put them away for the month.
- Take your #OOTD photo in the same place each day for consistency.

edurpotret/Instagram

mute_muse/Instagram

sitting_pretty/Instagram

natsu420/Instagram

#wearyourwardrobe #OOTD #mystyle #studio365challenge

FOODIE MONTH

♥ ♥ ♥ ♥ ♡

If you're a kitchen connoisseur or you just love food, challenge yourself to complete this 30-day food photo challenge.

☐ 1 Best breakfast
☐ 2 Street food
☐ 3 Kiss the chef
☐ 4 Gorgeous crockery
☐ 5 Grocery shopping
☐ 6 How I like my tea
☐ 7 Food market
☐ 8 Favourite fruit
☐ 9 Five a day
☐ 10 Clean it up
☐ 11 Guilty pleasure
☐ 12 Family dining
☐ 13 My kitchen
☐ 14 Raw
☐ 15 Preparation

☐ 16 Greens
☐ 17 Stovetop
☐ 18 Cookbook collection
☐ 19 Oldest gadget
☐ 20 Newest gadget

☐ 21 Midnight snack
☐ 22 Mix it up
☐ 23 Dining table
☐ 24 Finished dish
☐ 25 Dessert

☐ 26 Childhood favourite
☐ 27 Treat yo'self
☐ 28 Healthy eating
☐ 29 Unused gadget
☐ 30 Feast

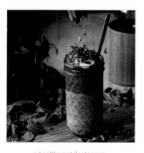

a.healthy.nut/Instagram

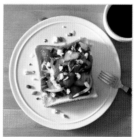

keiyamazaki/Instagram

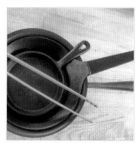

tinyhouserecipes/Instagram

#foodiemonth #lovetocook #bestbreakfast #studio365challenge

A COLOUR A DAY

♥ ♥ ♥ ♥ ♡

Limit yourself to only uploading photos in a certain colour scheme each day of the week. Keep this up for a month, or more, and you'll find your feed is a gorgeous rainbow.

Monday: Red

Tuesday: Orange

Wednesday: ... Yellow

Thursday: Green

Friday: Blue

Saturday: Indigo

Sunday: Violet

kirstinedahlkarlsen/Instagram

ashnagesh/Instagram

restl3ss /Instagram

awsome_world /Instagram

#acolouraday

#rainbow

#red

#studio365challenge

 GREEN FINGERS

Share your green fingered triumphs with your followers and show off the progress of your gardening endeavours from springtime seedlings to summertime blooms.

Focus

- Update your followers once a week so that they can see how your garden grows.
- Plant a seed and share daily updates on its growth. You'll soon see how quickly things can grow!
- No garden? No worries! House plants count too!

boobearsgirl/Instagram

twinklefingersboyd/Instagram

tribeandus/Instagram

foresthomelover/Instagram

#greenfingers #gardening #seeding #studio365challenge

SPRING CLEAN

♥ ♥ ♥ ♥ ♡

It might be a chore, or you may secretly like it, but every year it's great to blow away the cobwebs, organise your belongings and have a good Spring clean. Why not turn the chore into a photo opportunity?

Focus

- Show off your newly and neatly organised cupboards.
- Donating your unwanted items to charity? Why not share the process?
- If you're brave enough, show a before and after if something needed a really good clean.

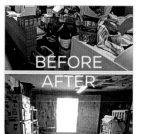

whatsupmoms/Instagram rosaangeljardon/Instagram kffamilymatters/Instagram catnip.tales/Instagram

#springcleaning #getorganised #dustbegone #studio365challenge

♥♥♡♡♡ BLOSSOM TREES

Once a year, when the blossom trees flower, the usual green landscape is transformed with soft pinks and purples. Capture these pops of colour and share with your followers.

Focus

- Capture the wind-blown blossom for an image full of movement.
- Use the blossom season as an opportunity for fashion photography and dress your subject to co-ordinate.
- Get up close for a soft, springtime shot.

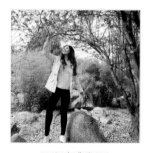
mamiseelen/Instagram

tatiana_yunitsyna/Instagram

nao_k_/Instagram

lanternsprite/Instagram

#blossomtrees #springtime #prettyinpink #studio365challenge

SUMMER SOLSTICE

Celebrate the longest day of the year with some gorgeous sunrise and sunset photos – it might be a long day but it'll be worth it!

Focus

- Travel to a different beauty spot for the sunrise and sunset.
- Join any local celebrations and photograph the individuals enjoying the solstice.
- Show your followers how much you're enjoying the long summer days in your photographs.

sabrinafausto/Instagram

selenafox/Instagram

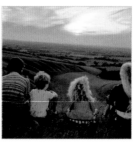

mariaelliott1991/Instagram

keerthi.operon/Instagram

#summersolstice #longestday #sunrisesunset #studio365challenge

ON MY HOLIDAY

Don't take the same holiday photos as everyone else. Focus your camera and see if you can snap a photo for each of these inspirational holiday hashtags.

- ☐ #packing
- ☐ #journey
- ☐ #currency
- ☐ #time
- ☐ #luggage
- ☐ #tickets

- ☐ #locals
- ☐ #souvenir
- ☐ #localdelicacy
- ☐ #architecture
- ☐ #thatview
- ☐ #sunrise

- ☐ #sunset
- ☐ #localnews
- ☐ #temperature
- ☐ #relaxation
- ☐ #adventure
- ☐ #statue

- ☐ #wildlife
- ☐ #tourists
- ☐ #somethingdifferent
- ☐ #language
- ☐ #atmosphere
- ☐ #timetogohome

antjenynke/Instagram

bretagnez/Instagram

tourdelust/Instagram

dariszcahyadi/Instagram

#myholiday #vacation #holidayalbum #studio365challenge

THE SPRING EDIT

During the season of spring fill your feed with your favourite spring things to celebrate the season of new life!

Focus

- Choose a colour that reminds you of spring and theme your photos around this.
- Document the change from winter to spring and from spring to summer.
- Turn your lens to the fashion world. What's on trend for spring?

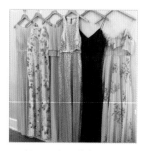

lajeunemariee_maids/Instagram

christian_tortu/Instagram

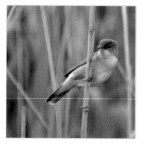

lee_cohen93/Instagram

black_n_whitelove/Instagram

#springedit #newlife #springtime #studio365challenge

THE SUMMER EDIT

Create a cohesive collection of photographs for the season of summer. Whether you're off on holiday or enjoying the long days at home, pick a theme and fill your feed.

Focus

- Pick your favourite songs of the summer and capture the lyrics in your photographs.
- Cool yourself down and focus on photos with a refreshing theme.
- Practise portraits during summer. Capture the fun moments you have with friends and family.

chinpua/Instagram

oldbluebbq/Instagram

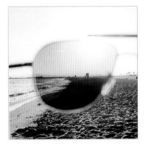
ryanlongnecker/Instagram

sayhellotoamerica/Instagram

#summeredit #sunshine #summertime #studio365challenge

THE AUTUMN EDIT

Autumn is a season filled with gorgeous colours, perfect for photographing. Capture your autumn days in a carefully thought-out edit.

Focus

- Stick to a colour scheme of reds, oranges and yellows.
- Document the season from the leaves changing colour to the first frost.
- Create an autumnal lifestyle edit. Include woolly hats and pumpkin carving!

sannalee/Instagram

akamediainc/Instagram

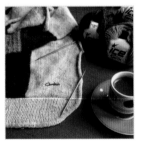

cocoshista/Instagram

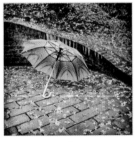

mestra art/Instagram

#autumnedit #changingcolours #fall #studio365challenge

THE WINTER EDIT

Those short, cold winter days and long, dark nights offer the perfect opportunity to create an enviable winter edit; whether you focus on the beauty of winter nature or on a cosy lifestyle theme.

Focus

- Venture out on cold mornings and capture the winter frosts.
- Turn your lens on the fashions of winter and create a lookbook.
- Keep your eyes peeled for winter wildlife.

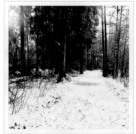
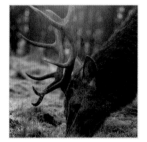

nw_fotografie_/Instagram norwegian_happiness/Instagram marie_maggs/Instagram tamnoonf/Instagram

#winteredit #itscoldoutside #wintertime #studio365challenge

TRAVEL COMPANION

If you're travelling or just on holiday take a small cuddly toy with you and include it in all your holiday snaps. This is a really fun way to share your adventures, especially with children!

Focus

- Aim to get a picture of your toy in front of iconic views.
- Create a unique hashtag so your followers can see the toy's adventures.
- Extend the toy's experiences to home life, too!

moonisky/Instagram

maryasegil/Instagram

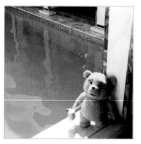

the_berkeley/Instagram

teds_travels/Instagram

#travelcompanion #tedontour #adventure #studio365challenge

NATIONAL PRIDE

Most countries have a national day to celebrate their nationhood. Show your pride and join in the celebrations! Try to capture a sense of pride, joy and celebration in your photographs.

Focus

- You could theme your photos on or around the day with your national colours.
- Street photography is a great way to capture impromptu moments of celebration.
- Celebrate all the national days and share the love around the world!

_holy_foxy_/Instagram jtorrejon90/Instagram ykmaus/Instagram nomad.worldwide/Instagram

#nationalpride #nationalday #celebration #studio365challenge

FATHER'S DAY

Share your favourite Dad moments, snaps or memories on Father's Day with this photo challenge.

Focus

- Create a portrait of your father.
- If you're a dad, snap a candid moment showing why you love being a father.
- Show your father through objects.

mamca_hyligana/Instagram

hotelbruc/Instagram

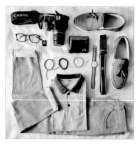

missymcxx/Instagram

iswahyugo/Instagram

#fathersday #ilovemydad #daddycool #studio365challenge

MOTHER'S DAY

Celebrate Mother's Day with this photo challenge. Sum up your own mother in one photograph!

Focus

- Recreate a beloved childhood photo.
- Create a flat lay of objects that remind you of your mother.
- If you're a mother, share why you love being a mum.

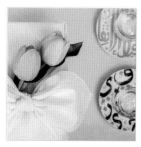

silsaldesignhouse/Instagram

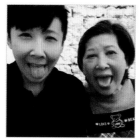

atom6322/Instagram

thegift_makers/Instagram

shifting_roots/Instagram

#mothersday #ilovemymum #motheringsunday #studio365challenge

AUTUMN LEAVES

Autumn is a time of warm tones and gorgeous light. So grab your camera and head out into the country for those awe-inspiring shots we all dream of taking.

Focus

- Grab a leaf and hold it up to the light for that fantastic bleeding edge shot.
- Move around and experiment with the light shining through the trees. Don't be afraid to shoot into the sun.
- Be prepared to explore. The next great shot might be just around the bend.

edithzuo/Instagram pumpkinspiceandallthingsice/Instagram bronnie.ware/Instagram icentralcoast/Instagram

#autumnleaves #autumn #autumncolours #studio365challenge

♥ ♥ ♡ ♡ ♡ # RAINDROPS ON WINDOWS

Rainy day photography, without having to get wet! Raindrops on windows can make really stunning photos, especially if there's something interesting outside. Get creative!

Focus

- Play with your focus. Try focusing on the raindrops, on an object inside and then on the view outside.
- Try to convey a sense of season. Is it a spring shower or a wintry storm?
- Test different filters and effects on your phone: up the contrast or add a vintage filter.

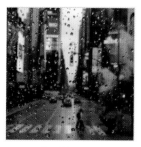

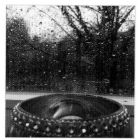

slbates2/Instagram quit.sugar.eat.well/Instagram selina_noir/Instagram kkp_2018/Instagram

#raindropsonmywindow #drizzle #rainydays #studio365challenge

FESTIVE PHOTOS

Spend the month of December focusing on the festivities and take a photo each day in the run up to Christmas.

- ☐ #lights
- ☐ #chocolates
- ☐ #sparkleandshine
- ☐ #holly
- ☐ #cards
- ☐ #cosychristmas

- ☐ #cupofcheer
- ☐ #christmasstory
- ☐ #tradition
- ☐ #christmastree
- ☐ #bauble
- ☐ #festivefilm

- ☐ #christmasthrowback
- ☐ #redandgreen
- ☐ #achristmascarol
- ☐ #wrapping
- ☐ #mincepies
- ☐ #christmasjumper

- ☐ #gingerbread
- ☐ #reindeer
- ☐ #fireside
- ☐ #christmascheer
- ☐ #homefortheholidays
- ☐ #pleasestophere

5ayf/Instagram

ali.horsfall/Instagram

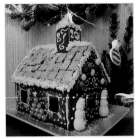

anastasiafeoktistova/Instagram

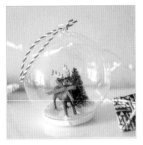

blossomandbear/Instagram

#festivechallenge #holidaysarecoming #day1 #studio365challenge

 WORLD RADIO DAY

Celebrate your radio station and radio DJs on the 13th of February. They shape musical tastes and reach millions of toe-tapping, cornflake-crunching homes and we love 'em!

Focus

- Turn this into a real project as you try and find the ultimate radio.
- They can be slick and cool, retro, clunky, digital, analogue, pretty or pretty ugly.
- What does radio mean to you and how does it fit into your day?

kilafm/Instagram jmm_md/Instagram thatvintagedarling/Instagram radiowinkel/Instagram

#worldradioday #radio #dabradio #studio365challenge

VALENTINE'S DAY

Celebrate love and fill your feed with red roses, hearts and all things romantic. If you're not celebrating this year, why not turn your feed into an #antivalentine protest?

Focus

- Be on the look out for romantic, candid moments.
- Create a flat lay of your cards or gifts – whether you're giving or receiving.
- Celebrate someone special with a Valentine's day selfie.

andreasmitides/Instagram

florist.co.klselangor/Instagram

jakedaniel.moore/Instagram

mellygphotography/Instagram

#valentine #february14 #loveisintheair #studio365challenge

EARTH HOUR

Every year in March, the world celebrates Earth Hour, by switching off lights and electronic devices. Light some candles, read a book or play a board game and capture some Earth Hour moments.

Focus

- Turn all your devices off and use an analogue camera during Earth Hour.
- Head out to a high point or a landmark and capture how many lights are turned off during Earth Hour.
- This is the perfect opportunity to capture some candlelight photographs.

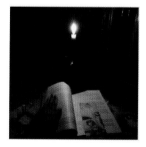
rikarie_wulan/Instagram

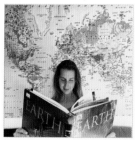
samyonthego/Instagram

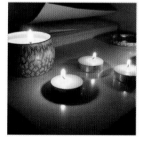
inasplitsecond/Instagram

rkoko/Instagram

#earthhour #noelectricity #candlelight #studio365challenge

INTERNATIONAL WOMEN'S DAY ♥♥♡♡♡

On the 8th of March, celebrate the wonderful women in your life or the women you admire the most!

Focus

- This cause focuses on empowerment and strength.
- Look out for specific focus which changes year on year.
- Think about what International Women's Day represents within your own life.

ashlimorris87/Instagram

beaevardone/Instagram

msrozlunn/Instagram

irma.widodo/Instagram

#internationalwomensday #womanpower #womanhood #studio365challenge

WORLD POETRY DAY

Celebrate your love of poetry on the 21st of March. Share your favourite poem or poet or tell the world how a good poem makes you feel!

Focus

- Recreate your favourite poem in an image.
- Share a favourite collection of poems or an image of a poet you have met.
- Give the gift of your own poetry to Instagram®!

k.dream_anew/Instagram

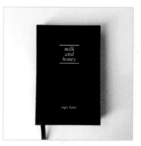

jennafarella/Instagram

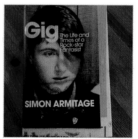

thinkingmark/Instagram

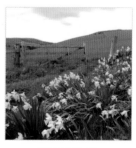

04lucy_y/Instagram

#worldpoetryday #poetry #poetryofInstagram #studio365challenge

PANCAKE DAY

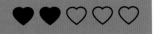

This challenge need not only apply to Shrove Tuesday — any day can be Pancake Day, and with some serious pancake artistry out there on social media, it would be rude not to.

Focus

- Get people together and have a pancake competition.
- Take some great table shots filled with pancake fare and condiments galore.
- Most importantly enjoy your pancakes!

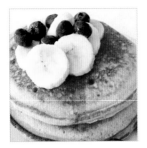

pcbilbondo/Instagram

amelia_98/Instagram

rawrindulgence/Instagram

a_little_normal_life/Instagram

#pancakeday #pancakeheaven #pancakeart #studio365challenge

♥ ♥ ♥ ♡ ♡ EASTER

Eggs, bunnies, flowers, chocolates, baskets, bonnets, chicks. What's not to love about Easter? It's a pretty happy time so share the joy.

Focus

- Create a virtual egg hunt – #spottheegg
- Or throw an egg hunt for real and get your friends and family involved.
- How many eggs are you planning to pig out on? Share your stash!

lush_ausnz/Instagram

lev_vackert/Instagram

sallysbakeblog/Instagram

delilah_alva/Instagram

#easterbunny #egghunt #easterdecor #studio365challenge

APRIL FOOLS' DAY

This April 1st tradition is gaining an online momentum. Be sure to share any good-willed pranks you have pulled or fallen for.

Focus

- Keep it light-hearted.
- Think about conveying your prank through an image.
- Fool your followers with a joke

johnnyumi0825/Instagram annasartjournal/Instagram therealcheytaylor/Instagram tunkunadia/Instagram

#aprilfoolsday #aprilfools #justkidding #studio365challenge

♥♥♡♡♡ INTERNATIONAL SIBLINGS DAY

This day happens each year on the 10th of April. If you don't have siblings of your own, take time to pay respects to your favourites. Whether it be a recent snap or a wonderfully amusing shot from the archives.

Focus

- Don't be afraid to portray the wackiest side of the relationship.
- Why not recreate a classic image from childhood?
- If you and your siblings can't be together, illustrate your relationship metaphorically.

candallai/Instagram

poppydeyes/Instagram

jdomingo82/Instagram

northsidefrench/Instagram

#internationalsiblingsday #siblings #siblinggoals #studio365challenge

EARTH DAY

The world really is your oyster with this one. How will you choose to praise this beautiful planet of ours? We look forward to seeing your efforts on the 22nd of April.

Focus

- It will be hard to confine your contribution so share multiple images to tell your story.
- Collect a selection of items that can represent all the things you love.
- The colour green has a powerful resonance for this occasion.

pinkrobotshirts/Instagram

drjacksonuk/Instagram

vivikitty2/Instagram

impressionssaratoga/Instagram

#earthday #earthdayeveryday #motherearth #studio365challenge

CELEBRATE SHAKESPEARE

The 23rd of April is not only Saint George's Day in England, it's also Shakespeare's birthday. Celebrate the birthday of the bard by snapping something spectacularly Shakespearean.

Focus

- Find a quote and take a photo to match: "grapes of wrath", "all that glisters is not gold", "let slip the dogs of war".
- Photograph something Elizabethan and celebrate the era.
- Quote Shakespeare and snap some his most famous words.

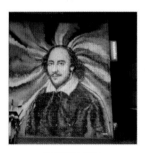

solelyrv/Instagram

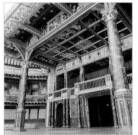

weltenbummlerinontour/Instagram

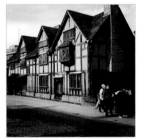

andste_official/Instagram

itsmenairobi/Instagram

#shakespeare #thebard #birthdayboy #studio365challenge

MAY THE FOURTH

Celebrate Star Wars day with a sci-fi or space-themed shot on the 4th of May. Make it as geeky or out-of-this world as you can. May the Fourth be with you!

Focus

- If you've got any sci-fi memorabilia or books around your house, make them your subject.
- Show off your geekiness with a sci-fi selfie.
- If you're not a fan, turn your lens skyward and capture the stars!

501stireland/Instagram smachester/Instagram theekatwoman/Instagram dave baeumler/Instagram

#maythefourth #maytheforcebewithyou #starwarsday #studio365challenge

 # INTERNATIONAL YOGA DAY

Calling all yoga fanatics! Grab your mat and get into downward dog on the 21st of June. You get the idea...

Focus

- Yoga is a portable pastime, where do you find the time?
- Get a group together or take a shot of your local class.
- Perhaps you've always wanted to give it a try, there's no better day to start!

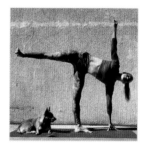

sensei dende/Instagram

jeremywulkan/Instagram

little bird yoga/Instagram

naya khanda/Instagram

#yoga #yogalove #yogaeveryday #studio365challenge

K-I-S-S-I-N-G ♥ ♥ ♥ ♡ ♡

Celebrate International Kissing Day with a smooching selfie on the 6th of July, whether it be with your dog, your budgie, your mum or your man.

Focus

- Think about perspective – who is giving the smooch?
- Give someone a surprise kiss and capture their reaction!
- Don't forget inanimate objects and good sandwiches might deserve a snog too!

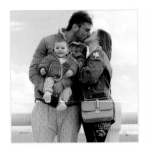
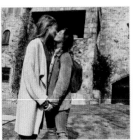

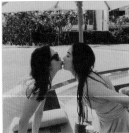

vanessa lancianese/Instagram nutellabcn/Instagram duygugoenel/Instagram secret girlfriends/Instagram

#kisses #kissing #kissable #studio365challenge

 # WORLD MENTAL HEALTH DAY

Few people would disagree that we need to do a great deal to improve awareness regarding mental health. Do your bit and get involved on the 10th of October.

Focus

- Your message can be subtle, a hashtag alone can be your message.
- Share something that represents someone you know who has struggled with their mental health.
- What message do you want to convey as support?

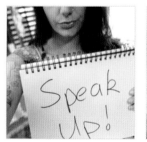
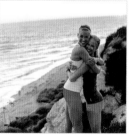

gypceemama/Instagram sulolga/Instagram the_bipolar_barbie/Instagram siss_fit/Instagram

#worldmentalhealthday #mentalhealthawareness #mentalhealthmatters #studio365challenge

HALLOWEEN

The opportunity for the spookiest photos falls on Halloween. See if you can take a photo for every prompt on this list during the Halloween celebrations. Get creative with your editing for some petrifying posts!

- [] Pumpkin carving
- [] A scary movie
- [] A haunted house
- [] A graveyard
- [] A cackling witch

- [] Halloween-themed food
- [] A cute costume
- [] A creepy costume
- [] A ghost
- [] A pet in a costume

- [] Trick or treat
- [] A vampire
- [] A werewolf
- [] A black cat
- [] A bat

- [] Black and orange pattern
- [] A skeleton
- [] What's under your bed?
- [] Boo!
- [] Spider's web

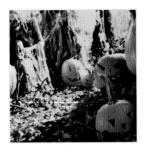

halloweendays/Instagram

thehalloweencollector/Instagram

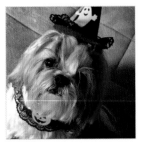

indyestilopet/Instagram

thehalloweencollector/Instagram

#halloween #spooky #creepy #studio365challenge

MOVEMBER

♥♥♥♥♡

The month of November is all about the moustache. With men growing 'tashes to raise money for worthwhile causes, it's the perfect opportunity to snap a picture of a moustache.

Focus

- Chart your own moustache journey from 1st to the 30th of November.
- Photograph friends, family and even strangers who have glorious moustaches.
- Can't grow one? Don a fake moustache and share a funny photo.

r3nanbatista/Instagram

traciecrommett/Instagram

ettunk/Instagram

hobbikats/Instagram

#movember #moustache #facialhairdontcare #studio365challenge

INTERNATIONAL MEN'S DAY

Who are the magnificent men in your life? Celebrate them and all the amazing men out there on the 19th of November.

Focus

- Take a picture of you and your favourite man/men.
- The candidate in question does not need to be in human form.
- The candidate also does not need to be an adult either!

philippeell/Instagram

radioflyerinc/Instagram

edgarramirez25/Instagram

laurenheather/Instagram

#internationalmensday #mainman #men #studio365challenge

 BEST 9

At the end of the year use the best nine tool to find out which nine of your Instagram® photos received the most likes and share the collage with your followers.

Focus

- Use the best nine website to find out your most liked photos...
- ... or decide which nine photos from the whole year were your favourites.
- This is also a great way to see what kinds of photos are popular!

meganwilsonphotogram/Instagram

twillandprint/Instagram

victoriawestphotography/Instagram

the_blue_brothers/Instagram

#best9 #myyear #bestphotos #studio365challenge

SMILE

"Smile for the camera!" Capture happy moments, from sly grins to full-on belly laughs.

Focus

- Turn the camera on yourself. Selfie smile!
- Capture smiles caused by you.
- Aim to post one smile for each day of the month.

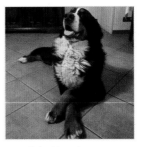

vaitsou_eleni/Instagram kid_kong_noris/Instagram luciaonlyberner/Instagram sii86/Instagram

#smilechallenge #laughter #happiness #studio365challenge

♥♥♥♡♡ SEVEN SELFIES

Selfies are the most tagged photo-type, so why not embrace that? Take a selfie at exactly the same time each day for one week.

Focus

- Extend the challenge to a month or even a year.
- Take your selfie when you wake up.
- Try an unusual angle. As long as you're taking a photo of yourself, it's a selfie!

brendahiguera/Instagram

claudiodangeloreal/Instagram

sophieaveryb_23/Instagram

michellephan/Instagram

#selfie #sevendayselfie #day1 #studio365challenge

HOURLY SELFIE

Document your day through the art of the selfie. Take a selfie every hour on the hour, from the moment you wake up to the moment you go to bed.

Focus

- Complete this challenge on a day when you're doing something interesting or different...
- ... or document your every day life!
- Don't spend time posing or finding the perfect spot. Take that selfie exactly on the hour, no matter what!

halt_anders_/Instagram

jleevillanueva/Instagram

hunter_agnew/Instagram

xjlud369/Instagram

#hourlyselfie #myday #selfietime #studio365challenge

JUMPSTAGRAM

Jumping photos are totally on trend at the moment; whether it's a group of friends jumping for joy on a beach holiday, or a wedding party celebrating the big day. Take this trend to the next level and be creative. Get down low and use the burst mode on your camera to get the best shot.

Focus

- Use props such as balloons or an umbrella and try to make it look as if your subject is floating away.
- Try creating interesting shapes on the jump, rather than just jumping up and down.
- Take a jumping selfie. You may need to use a timer or a remote!

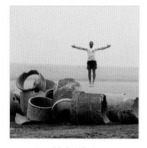
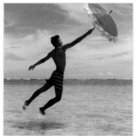

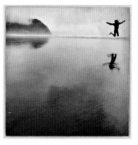

stevenjohnbond/Instagram taruno.etto/Instagram zaiyn4/Instagram hopefulrobin/Instagram

#jumpstagram #floating #jumpology #studio365challenge

NO FACE PORTRAIT

This is a different spin on a traditional photographic portrait. Take a photo of your subject without showing their face. Be creative and try to get the subject's personality across.

Focus

- Take a backwards portrait.
- Crop off the top of the head and focus neck downwards.
- Obscure the face by using objects in the foreground.

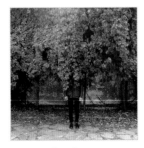
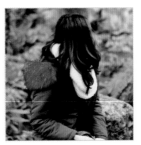

nadin_me/Instagram real_ycsoldier/Instagram soulstamina_archive/Instagram wallaceknows28/Instagram

#nofaceportrait #facelessportrait #replaceface #studio365challenge

CANDID CAMERA

♥ ♥ ♥ ♥ ♥

This challenge is all about capturing candid moments. You'll need to be a photography ninja to take photos without your subjects realising!

Focus

- Be brave and undertake some street photography.
- Capture family moments at your next gathering.
- Aim to capture a range of emotions.

streetjam.ist/Instagram

thelaxsalmon/Instagram

lili.setya/Instagram

airlangga.g/Instagram

#candidcamera #streetphotography #candidmoment #studio365challenge

PET PORTRAIT

Everyone loves seeing a cute pet photo! Snap some portraits of your own, or a friend's pet and share with your followers. It's almost guaranteed lots of likes!

Focus

- Try to get an action shot. Use the burst mode and choose your favourite.
- Capture a funny moment – always be ready to take a photo!
- Aim for something artistic. Think about angle and composition, but be quick!

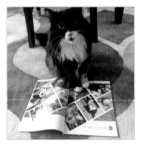

phluffy_phoebe/Instagram

jiujiu_geigei_me/Instagram

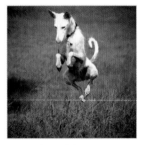

flechaslife/Instagram

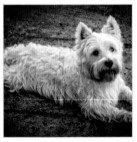

ajitdebphotography/Instagram

#petportrait #socute #fluffy #studio365challenge

♥ ♥ ♥ ♥ ♥ # STRANGER SELFIE

Spend a month taking selfies with people you don't know! Always ask permission from your subject and explain what you're doing. You might even make a new friend!

Focus

- Choose people with an interesting look.
- Find people in interesting settings.
- Take a range of silly and serious selfies.

jazemoncus_51/Instagram

awkward_pet_selfie/Instagram

tommasocarraro/Instagram

jennae.lyn/Instagram

#strangerselfie #newfriend #selfietime #studio365challenge

REPLACE MY FACE ♥♥♥♥♡

This fun twist on the selfie or portrait sees the face replaced, usually by holding up an alternative face image in front of the subject's face.

Focus

- If you're a vinyl fan, create a series of portraits using sleeve art.
- Try replacing the face with something unusual or unexpected.
- If you're artistic, you could doodle a picture and then hold it up to your face.

sunflowercreature/Instagram

simonchaytor/Instagram

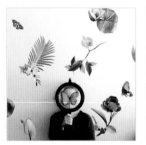
weareblooming/Instagram

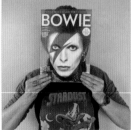
merileeloo/Instagram

#replacemyface #portrait #selfiewithatwist #studio365challenge

SELFIE FROM THE PAST

We've been turning the camera on ourselves since the dark days of MySpace. Trawl back through your selfie archives for a whole week. On day 1, find a selfie from 1 year ago, on day 2, share a selfie from 2 years ago and so on until you reach day 7!

Focus

- Go back even further and share your oldest selfies.
- Share some of your most cringe-worthy selfies from the past.
- Recreate the selfies and post them alongside each other.

kptnblau/Instagram

shesxaxkilla/Instagram

suzanna1996/Instagram

xrussiasfinest713/Instagram

#selfiefromthepast #1yearago #cringe #studio365challenge

WEDDING GUEST

Weddings are great opportunities for budding photographers to practise. Leave the staged shots to the professionals and shoot some candid photos of the wedding party and guests. See if you can tick off all these shots at the next wedding you attend!

- ☐ A kiss
- ☐ Holding hands
- ☐ Happy tears
- ☐ A stolen glance
- ☐ The cutest couple
- ☐ People laughing

- ☐ A beautiful dress
- ☐ A bow tie
- ☐ The first dance
- ☐ A bouquet
- ☐ Appertisers
- ☐ Speeches

- ☐ Confetti shot
- ☐ Synchonised dancing
- ☐ A fabulous hat
- ☐ Bare feet
- ☐ Ring bearer
- ☐ Cake

- ☐ A silly face
- ☐ Your place setting
- ☐ The table plan
- ☐ The little details
- ☐ Proud parents
- ☐ The youngest guest

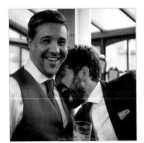
emmapembertonphotography/Instagram

portraitwizard/Instagram

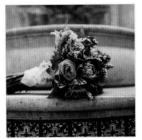
rochavezwp/Instagram

suziphotography/Instagram

#weddingguest #brideandgroom #happilyeverafter #studio365challenge

CHALK PHOTOGRAPHY

Great for kids or those who are young at heart – this is a great way to take a creative portrait. Use your artistic skills to create a chalk backdrop, and then position your subject into the scene and shoot from above.

Focus

- Become a sidewalk superhero and make it look as if your subject is flying!
- Pass the chalks to a child and let them create their own world.
- Live your dreams in chalk form: become a princess, a pirate or transport yourself to paradise!

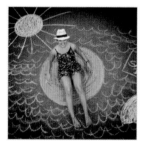

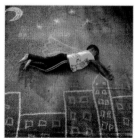

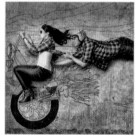

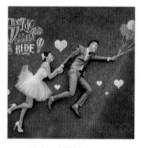

m0n4li/Instagram jessmaria37/Instagram steffi_ha/Instagram thelouvrebridal/Instagram

#chalkphotography #chalkart #sidewalksuperhero #studio365challenge

SELF PORTRAIT

We're all selfie experts now, but what about self-portraits? Becoming the subject from a distance. Become a part of your own works of art, because who better to take an amazing image of you than you!

Focus

- This is all about location and expression.
- Think about your surroundings and the emotions you may want to convey.
- Don't be afraid to get out in public and have fun with it.

photonarz_/Instagram

kellythibeaultphotography/Instagram

nataliyaps/Instagram

anthonyhardingfuller77/Instagram

#selfportrait #selfportraitchallenge #selfportrayal #studio365challenge

 FAMILY TREE

Delve into your family history and share a series of family portraits. Go back as far as you can and accompany each picture with an anecdote about your ancestor.

Focus

- Use the multiple photo feature to show a branch of the family, or one person at different ages.
- Start with your oldest ancestor and work back to yourself, so your feed shows everyone in order.
- Why not try to recreate the portraits and look for any family resemblances?

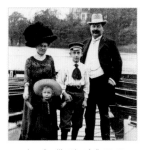

andreas.bendlin.schwerin/Instagram

scansquad/Instagram

breathewunder/Instagram

storm_flow/Instagram

#familytree #ancestors #familyresemblance #studio365challenge

NEWBORN PORTRAIT

The first photos of a brand new baby are some of the most exciting and most treasured photographs for a parent. Whether it's your own child, or a family or friend's new addition, creating a newborn portrait is a very special project.

Focus

- Try to take a portrait whilst the newborn is awake – everyone wants to see their beautiful eyes...
- ... but a sleeping portrait is just as cute – capture a peaceful moment.
- Involve any older siblings in the portrait.

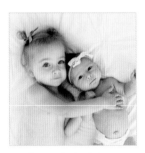
dear.november.days/Instagram

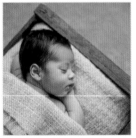
marinatoledofoto/Instagram

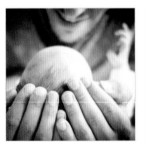
3d.bebe/Instagram

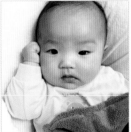
mikeyuiop/Instagram

#newborn #welcometotheworld #family #studio365challenge

♥ ♥ ♥ ♥ ♡ # MICROFASHION

Spot and photograph future fashionistas with this adorable challenge. Snap pictures of your own or family and friends' children who are rocking the latest fashions. If you're photographing on the street, make sure to get a guardian's permission before taking the photo.

Focus

- A fashion photo shoot could be a fun afternoon for both you and the child.
- Encourage the kid to act the part too: if they're dressed as a diva, get them to pose!
- Try to capture candid, natural moments as the child enjoys their microfashion!

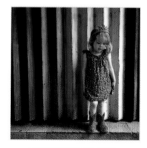
catcatbabycatfood/Instagram

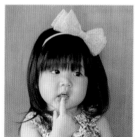
petitetroopers/Instagram

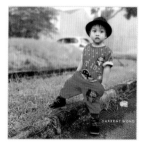
darrent wong/Instagram

zivotchrobaka/Instagram

#microfashion #futurefashionista #stylishkids #studio365challenge

FAMILY PORTRAIT

Gather your family or friends together for a group portrait. Aim to show the personalities of each individual in the photo. Think carefully about your settings, angle and perspective.

Focus

- Take some serious portraits...
- ... and then ask everyone to do something funny and snap away!
- Take some candid portraits for natural poses and interactions.

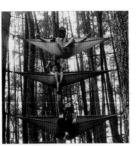

marlmcphotos/Instagram storyipot/Instagram raff_rafara/Instagram three_owls_studio/Instagram

#familypotrait #myfamily #familygathering #studio365challenge

 TWO IS COMPANY

Take a portrait of a perfect pair. From partners to BFFs, dynamic duos to gruesome twosomes, it's more fun than one!

Focus

- Ask your pair to pose for you and take some fun portraits...
- ... or take some candid photos for natural moments.
- Create a series of portraits to share with your followers.

angmthompson/Instagram

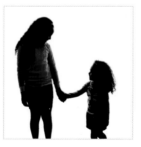

rosieposiewoo/Instagram

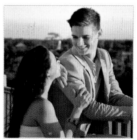

autumnrobinsonvs.theworld/Instagram

sullydoodle/Instagram

#twoiscompany #dynamicduo #gruesometwosome #studio365challenge

A MILLINER'S PARADISE

Are you a hat person? Do you have a favourite beanie, fedora or bonnet? Be a part of the hat appreciation society!

Focus

- Get some fellow hat-lovers involved and ask them to pose.
- If you have many examples of excellent headgear, create a gorgeous arrangement...
- ... or take multiple selfies to montage into a hat-adulation post.

bgoodtheblog/Instagram

esemeefascinators75/Instagram

gtawedding.ca/Instagram

herringtoncatalog/Instagram

#hats #headwear #hatsofInstagram #studio365challenge

♥ ♥ ♥ ♥ ♡ TINY PEOPLE

The world is a huge place and us humans are just a tiny part of it. Take an urban or natural landscape shot with tiny people in situ to show just how vast the landscape is.

Focus

- This is a great shot for street photographers – look for those unposed moments.
- For natural landscapes try to get as far away from your subject as possible to make the landscape look empty.
- Use a tilt shift effect to enhance your photograph.

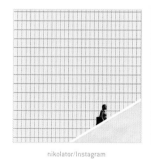
nikolator/Instagram

lessher/Instagram

de.mara/Instagram

ryo5748/Instagram

#tinypeople #hugelandscape #minimalist #studio365challenge

SHOES

As a beloved film character once pointed out: you can tell a lot about a person from their shoes. Create a portrait of yourself or a loved one through their shoes.

Focus

- This is a great way to capture a family portrait – look out for shoes lined up at the door.
- Try to show a person's personality through their footwear.
- Why not share your current mood through a shoe update each day?

bukombingiyim/Instagram

pindolly/Instagram

vani.ra/Instagram

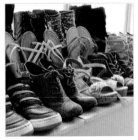

ashmcraig1992/Instagram

#shoes #shoeportrait #madeforwalking #studio365challenge

ONE LIGHT PORTRAIT

Harness a single light point to create dramatic portraits of your friends and family.

Focus

- Use a dark area with either one point of natural or artificial light.
- Place your subject to take advantage of both the light and shadow.
- These types of photos look great in black and white. Experiment with your filters.

rotsagarcia/Instagram

bobaproma/Instagram

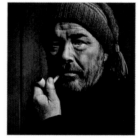

russellcobb/Instagram

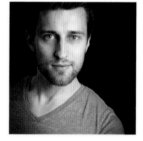

rosemaryrance/Instagram

#onelightportrait #lightandshadow #portraitphotographer #studio365challenge

PHOTO BOOTH FUN

Next time you're hosting a party, set up your own photo booth. This can easily be done with a digital camera, tablet or smartphone, tripod and a remote shutter-release button.

Focus

- Provide props for your party guests and they won't be able to resist!
- Create a collage of the best photos of the night, or share them all!
- Use a smartphone printer to give your guests instant copies.

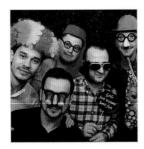
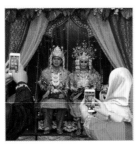

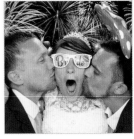

happyeventstime/Instagram jhonsphoto/Instagram awsnapbooths/Instagram klikphotocy/Instagram

#photoboothfun #diyphotobooth #party #studio365challenge

 SPORTS FAN

Action shots of athletes and sports people, professional or not, are dynamic and exciting photos to take, no matter whether you're attending a league match or supporting a local event.

Focus

- Use a fast shutter speed to photograph individuals or teams mid-game.
- Turn your lens on the fans for some interesting reaction shots.
- Look for moments of triumph, or defeat and capture the raw emotion.

brandonwinship016/Instagram csibi_l_csaba/Instagram isa_zac/Instagram runner_89/Instagram

#sportsfan #inthegame #actionshot #studio365challenge

DOGS AND THEIR OWNERS

There's a saying that dogs always look like their owners! Set up some pooch portraits with your family and friends and look for the similarities.

Focus

- Set up a formal photo shoot and dress the set to suit the dog and owner's personalities...
- ... or go for a walk with the pair and take some relaxed photos.
- Experiment with close ups, action shots, long shots and everything inbetween!

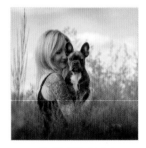

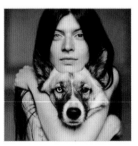

bb_snapshot/Instagram

valy_designforlove/Instagram

dogswaitforyou/Instagram

servicedog.makki/Instagram

#dogandowner #resemblance #dogperson #studio365challenge

FANCY DRESS

Next time you're invited to a fancy dress party, play the part of photographer and ask the party guests to strike a pose befitting their character.

Focus

- Look for people whose costumes work together and set up a group shot.
- Capture candid moments – Batman singing karaoke would make a surreal and fun photo.
- Take advantage of any lighting or décor to add atmosphere to your portraits.

elmo_gets_fun_and_creative /Instagram

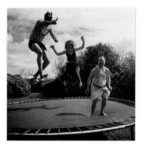

newdirectionforyou/Instagram

ndawson85/Instagram

richterdiaaa/Instagram

#fancydress #partytime #themedparty #studio365challenge

SILLY SAUSAGE

No matter a person's age, there are always moments when they just want to be silly. Next time a friend or family member is in a silly mood, turn the camera on them for a fun portrait!

Focus

- If someone is in a funny mood they're more likely to play up for the camera.
- Try to make them giggle and capture them mid-laugh.
- Infectious mood? Take a group photo of everyone pulling a funny face.

onthegrindtravel/Instagram

rebekahdee_93_/Instagram

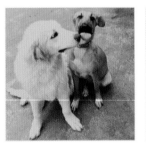

janette_s/Instagram

abangoldrick/Instagram

#sillysausage #gotthegiggles #funnybusiness #studio365challenge

♥ ♥ ♥ ♥ ♡ PORTRAITS WITHOUT PEOPLE

This requires thought. What makes you, you? We are made up of the things we love, what we do and the stuff we have. Capture the essence of a person, without them.

Focus

- You can focus on a selection of belongings, a favourite place or thing to do.
- You are encapsulating a personality or a moment with someone.
- Or perhaps it's a portrait of yourself and what you're up to right now.

jrafaeldomingo/Instagram

belle_ellery/Instagram

tif.tac.toe/Instagram

portraitswithoutpeople/Instagram

#portraitswithoutpeople #conceptart #selfportrait #studio365challenge

PROFILE

A profile is a very particular portrait style that creates an intimate, almost vulnerable, view of the subject. Take a photograph of your subject in profile.

Focus

- It's possible to catch people off-guard with this portrait style, giving a natural effect.
- Alternatively, you can go to the extremes of pose and drama here.
- You can play with colours and silhouettes to create the most striking results.

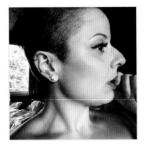
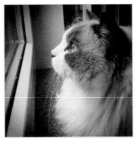
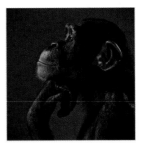

baronne_athi/Instagram watashi_alexa/Instagram ynanimals/Instagram 2dudesshopping/Instagram

#profile #profilephoto #profileportrait #studio365challenge

♥ ♥ ♥ ♥ ♡ # ALL IN THE HANDS

Old, young, perfected, nail-bitten, chapped, polished... in all their glory. Hands help us express so much and physically deal with everything life throws our way. Create a portrait featuring only hands.

Focus

- Celebrate the differences in the hands of those you know.
- Try to show a sense of personality through the hand portrait.
- Juxtapose young and old, male and female, etc.

susa_ortiz/Instagram

justinebackes/Instagram

earth_and_wind_by_lucky/Instagram

piliguoglielmi/Instagram

#hand #myhands #fingers #studio365challenge

HELLO

From long-awaited meetings to a quick hello, make sure you've got your camera ready next time you're meeting with your friends or family to capture those candid greetings.

Focus

- If you're meeting someone you've not seen for a long time, document the reunion.
- Look out for touching moments at train stations and airports for some street-style photography.
- Take a hello selfie to start your Instagram® day!

owliasarah/Instagram

thesparrowschool/Instagram

misfloo/Instagram

o.da.claudia/Instagram

#hello #greetings #longtime #studio365challenge

♥ ♥ ♥ ♥ ♡ GOODBYE

Parting is such sweet sorrow. Capture the bittersweet moments of goodbyes in photos.

Focus

- If you're leaving a holiday destination, wave goodbye to the land and the locals.
- If you're at an airport look out for candid moments – but don't intrude!
- Ask your friends for a final pose just before you depart. Ciao!

somefin2vibe2/Instagram

winston goldenretriever/Instagram

vanessabingham /Instagram

ofais_/Instagram

#goodbye #parting #solong #studio365challenge

THE LOOK OF LOVE

♥♥♥♥♡

Capture the look of love on someone's face whilst gazing at their beloved. Perfect for candid shots and plenty of opportunity for humour.

Focus

- Next time you're at a wedding try to capture glances between the newlyweds, or even loved-up guests.
- Adoring animals often look to their owners with love in their eyes.
- Ever wish someone would look at you the way they look at food? Capture someone's food-love face.

 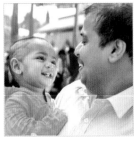

royalmemoriesphotography/Instagram fetchandfollow/Instagram dfmexicodiner/Instagram ganeshsonar/Instagram

#thelookoflove #adoration #foodloveface #studio365challenge

PAINT POWDER PORTRAIT

Whether you're celebrating the Hindu holiday of Holi, participating in the Colour Run or just want to create a colourful portrait, paint powder adds fun to your photos.

Focus

- Capture the puffs and clouds of the paint powder as it's thrown...
- ... or photograph the aftermath and ask your subject to pose.
- Get in the middle of the event or festival and keep snapping for candid, colourful shots.

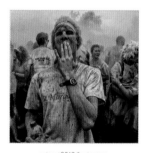

cstreet2013/Instagram

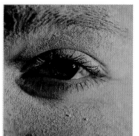

aalex.wills/Instagram

braemarcollegewoodend/Instagram

ddphotoever/Instagram

#paintpowderportrait #colourrun #holi #studio365challenge

CURIOUS ANIMALS

♥♥♥♥♡

Every now and then you'll be trying to photograph an animal, and it simply won't pose for you as it's more interested in the camera. Turn this into an Instagrammable moment and capture that curious animal in a photo.

Focus

- Incentivise pets to get close with a treat placed near the camera.
- Turn your flash off, so you don't scare your subject.
- Always be wary of wild animals and don't do anything to distress the animal.

alnunez58/Instagram

lemur4o/Instagram

renners_art/Instagram

lightcapturedbydamian/Instagram

#curiousanimals #closeup #brave #studio365challenge

❤ ❤ ❤ ❤ ♡ MY HERO

This portrait is all about exploring who you look up to. Who's your hero? If you're able to, ask them to pose for a photograph. If you're unable to photograph them in person, create an image that shows who they truly are.

Focus

- If you look up to a friend or family member, ask them to pose for you and aim to create a touching portrait.
- If your hero has passed away, dig out some old photographs and share their life in pictures.
- Perhaps your hero is a celebrity? Share a portrait of yourself being inspired by them.

dianyunitasaritris/Instagram

biancaprice/Instagram

fiercelychelsea/Instagram

mlharker1/Instagram

#myhero #idol #respect #studio365challenge

FACE SPLIT ♥ ♥ ♥ ♡ ♡

This photo challenge has the potential to uncover some intriguing, and perhaps worrying, similarities between individuals. Simply snap a couple of front-facing portraits and edit them together to create one face.

Focus

- Experiment with members of the same family to highlight resemblances.
- You could also try out human and animal combinations!
- You may find it easiest to take lots of portraits and play around with the best fitting pair.

katrinadoerr15/Instagram

christianrigal/Instagram

seth_johnson/Instagram

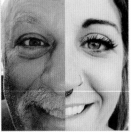

mskarli/Instagram

#facesplit #twofaces #genetics #studio365challenge

♥ ♥ ♡ ♡ ♡ LAUGHTER LINES

They say it's the best medicine. It's certainly a guaranteed way to capture someone at their most genuine and naturally beautiful.

Focus

- It's all about ensuring it's as natural as possible, fake laughter is easy to spot.
- You need to be ready to react at the 'moment' so be alert.
- It's impossible to get a bad laughter shot so go for it!

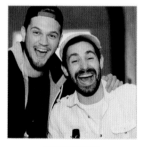
jae.gab/Instagram

kolp.photography/Instagram

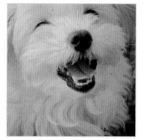
thaishow3/Instagram

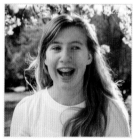
bethany_roberts /Instagram

#laughing #laughter #laughingdog #studio365challenge

EMOTIONS

It's easy to capture a photo of someone when they're happy, but other complex emotions can be difficult to convey in a photo. Use your camera candidly and try to capture real, raw emotions.

Focus

- Children rarely hide their feelings and are a great subject for this challenge.
- Happiness is a great emotion to capture, but see if you can capture it in an unusual way for this image.
- Use your judgement when photographing people who are feeling emotional – the last thing they might want is a camera in their face!

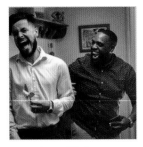

izzy_cam87/Instagram

zamudiooohh/Instagram

bethdelagi/Instagram

terribletwosdays/Instagram

#emotions #feelings #raw #studio365challenge

 OSCARS® SELFIE

It's one of the most iconic selfies ever taken. Recreate the Oscars® selfie with your own friends. Get as many people in the frame as possible.

Focus

- Next time you're at a party shout "SELFIE" and see how many people clamour into your photo.
- No selfie sticks allowed – give the camera to the person with the longest arms.
- For an extra challenge, recreate the original and ask your friends to dress up!

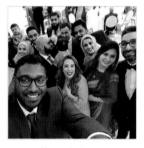 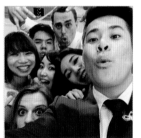 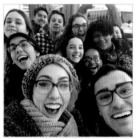

king.omz/Instagram hoangio/Instagram kaykerimian/Instagram ls4a535/Instagram

#oscarsselfie #lotsofpeople #extremeselfie #studio365challenge

Oscar® and Oscars® is a registered trademark of the AMPAS.

HYGGE

The concept of cosiness from Denmark is all about creating a warm atmosphere, enjoying the good things in life and surrounding yourself with the people you love. Capture your hygge moments – perfect for the colder months.

Focus

- Show your followers the unusual things that make you happy.
- Spend a month (perhaps December) capturing moments of hygge.
- Focus on details in your home that embody hygge.

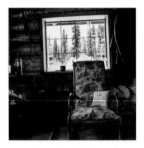

country_and_inspiration/Instagram

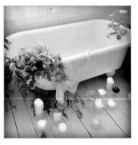

trucosparadecorar/Instagram

kathryn_armitage/Instagram

zezowatasowa/Instagram

#hygge #getyourhyggeon #cosy #studio365challenge

♥♥♥♥♡ # GET HEALTHY

Start a health kick with this month-long challenge. Each day photograph something healthy, from your exercise routine to a deliciously wholesome meal.

Focus

- Chart your exercise journey for a whole month.
- Challenge yourself to cook a different, healthy meal each day.
- Extend the challenge to show your healthy lifestyle transformation.

theonlytawfiq/Instagram

bighealthgoalie/Instagram

yolaholic/Instagram

juszczakdavid/Instagram

#gethealthy #healthyeating #exercise #studio365challenge

THE FLAT LAY

These photos are all about the planning and the styling. Lay out your favourite objects or current obsessions in a pleasing way and snap from above.

Focus

- Keep your flat lays themed, whether it's colour or object type.
- Lay out your ingredients before cooking, and then of course share a photo of the finished meal.
- This is a great twist for your #OOTD photos, too. Lay your outfit out and take a photo!

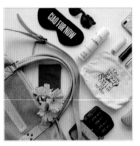

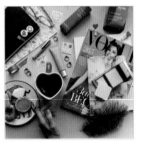

edihartonoliem/Instagram

jessicaluxe/Instagram

thefashionfraction/Instagram

mylizaveta/Instagram

#flatlay #myobsessions #styledshot #studio365challenge

 # LOVE WHAT YOU DO

Whether you're working, studying or looking after the kids, try to capture one thing a week that shows why you love what you do.

Focus

- Show a "behind the scenes" or "sneak peek" of what you're working on.
- Take a photo a day for a whole month.
- Share something others may find mundane and explain why it makes you happy!

angelyn_stroud/Instagram

monikavikenleithe/Instagram

melarrebola/Instagram

panache_myos/Instagram

#ilovewhatido #workperks #lovemyjob #studio365challenge

QUOTABLE

Overlay your photographs with an inspiring or poignant quote. The photo and the quote should work in harmony to say something about the subject, or about how you're feeling.

Focus

- Focus on one poet or writer and spend a week taking photos to go with their words.
- Take a landscape photo and search for the perfect quote to overlay.
- Use a photo and a quote to reflect the moment personally for you.

growup.daily/Instagram

inspiring.quotes.a/Instagram

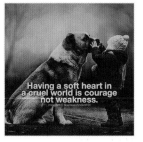

spiritualweirdo/Instagram

porfigood/Instagram

#quotable #quoteoftheday #wisewords #studio365challenge

♥♥♡♡♡ SHELFIE

Share your love for books with an inspiring #shelfie. Take a snap of your bookcase to show off your collection, current reads or your book organisation (now, should it be by author or book colour...?).

Focus

- Give your followers a guided tour of your bookcase by using multiple photos.
- Do you have anything else on your shelves? Show it off!
- Show off your favourite books or current reads.

brooklynbookdreamer/Instagram

jagos_pony/Instagram

tim_miller_/Instagram

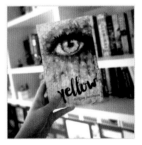
pinkbooots/Instagram

#shelfie #bookstagram #bookworm #studio365challenge

MORNING ROUTINE

Make the mundane magical and share your daily morning routine with your followers. Utilise 'Stories' or multiple photos to create a chronology for your fans!

Focus

- If you're taking a series of photos, try different styles. From selfies and portraits to flat-lays and point-of-view shots.
- Share an 'out-of-the-ordinary' morning routine.
- Create a story on the fly, and show the chaos or calm of your average morning.

24fit_chick/Instagram

den.sa90/Instagram

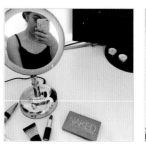

mrs_ilona/Instagram

johanna.stayyourself/Instagram

#morningroutine #goodmorning #adayinthelife #studio365challenge

THE JOURNEY

If you're travelling somewhere (for work, or leisure) why not document the journey itself? From your method of travel to the views out the window, your followers will love travelling with you.

Focus

- Create a story using short videos and photos.
- Going on a road trip? Make sure to stop at all the viewpoints.
- If your journey is getting mundane, spice it up by trying some new photography techniques or filters.

audecoco/Instagram

explore.with.hannah/Instagram

rashmigautam/Instagram

freemandarina/Instagram

#thejourney #roadtrip #onmyway #studio365challenge

SHOOT FROM THE HIP

Next time you're out shoot "from the hip" by taking photos without looking through the viewfinder (or screen). Shoot as you walk, aiming your lens at anything interesting. You'll probably only be able to use 2 or 3 out of 100 shots, but those few will be worth it!

Focus

- Try to capture moments between people.
- Aim for some interesting architectural shots from a different angle.
- Step back and observe the hustle and bustle and see what you can capture.

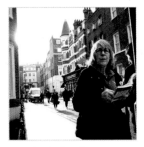
lucasjmahoney/Instagram

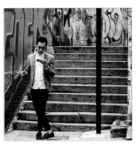
jjsooner/Instagram

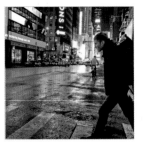
jsarnerphoto/Instagram

volgoxstreet/Instagram

#shootfromthehip #candid #streetphotography #studio365challenge

♥ ♥ ♥ ♥ ♡ BREAKFAST

The most important meal of the day deserves the spotlight. Why not challenge yourself to a month of brekkie variety? You will not only have the yummiest starts to your days, but may inspire those reaching for yet another bowl filled with flakes of corn!

Focus

- Provide instructions so that people can try out your recipes for themselves.
- Think of a theme for each week – blueberries, oats, eggs...
- ... you may discover a new favourite!

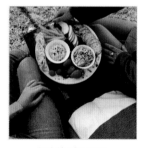
jessie_khoo/Instagram

saroqwithsomeguac/Instagram

williamsburgfresh/Instagram

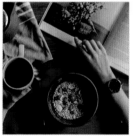
williamsburgfresh/Instagram

#breakfastclub #breakfastlover #breakfastgoals #studio365challenge

FIVE-A-DAY

What better way to keep track of healthy eating and to encourage others to monitor theirs than to upload a regular five-a-day food diary and share snaps of the fruit and veg you eat on a daily basis. It's one of the healthiest photo-feed habits you could think of.

Focus

- You could post each bit of fruit and veg as you're tucking in...
- ... or artistically collate the images at the end of each day.
- Challenge yourself to try something unusual... interesting fruits make interesting photographs!

alexandrarosecreative/Instagram

anf_adventures/Instagram

mr_broadbent /Instagram

kiwette23/Instagram

#fiveaday #fiveadaygoals #fiveadayproject #studio365challenge

♥ ♥ ♥ ♡ ♡ I WAKE UP FEELING...

This challenge is not for the faint-hearted. Each morning for a set period of time (or forever!) you must take a selfie before you rise from your pit. Your comment and edit must reflect your mood. Think of it as the most honest of diaries!

Focus

- This experiment will document the highs and lows of waking up to a new day.
- It will provide you with memories of how you may have felt before a big challenge or exciting day.
- It will also encourage you to meet each day with positivity.

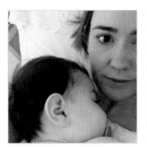

evilmike198/Instagram mariafloare/Instagram sarahbird84/Instagram goliaththedog/Instagram

#stillinbed #morningface #ilovemybed #studio365challenge

OUTFIT OF THE DAY

This trend is for all the fashionista's out there! Despite the pre-planning, its simple really – just lay out your outfit for the day to show off the style you'll be trailblazing. You can alternatively take a pic of yourself in said outfit for full effect, if you prefer.

Focus

- You could do this for a whole week or on special occasions.
- Planning is key.
- It's good motivation to use your wardrobe effectively.

mathildechvff/Instagram

madejromodena/Instagram

gorgeous_daily_dose/Instagram

jessicaxia/Instagram

#outfitoftheday #todayiamwearing #outfitinspiration #studio365challenge

WHAT'S IN MY BAG?

♥♥♡♡♡

It's a YouTuber trend, so why not translate that to Instagram®? Find some willing participants (or your whole collection of bags) and make this a regular addition to your profile.

Focus

- Present the contents as a flat lay.
- Look for commonality with a friend's handbag/manbag/camerabag faves.
- If you wanted to switch things up, why not try #whatsinmypocket?

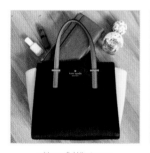
caitbrownfield/Instagram

justin.travel/Instagram

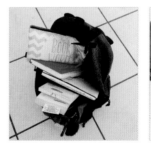
tassasharesthiswithyou/Instagram

stinadiane/Instagram

#whatsinmybag

#mybag

#bagoftheday

#studio365challenge

COFFEE

♥♥♡♡♥

Many of us rely on coffee these days and with new varieties being named on an almost weekly basis, there is plenty of opportunity for some gorgeous photos! If you're a fan make sure to snap and share pictures (and reviews) of your favourite drinks and coffee houses.

Focus

- Treat yourself to local speciality shops and share your recommendations with friends.
- Ensure you brave new flavours and styles!
- Share photos of cool coffee house vibes.

mariacastelbranco/Instagram

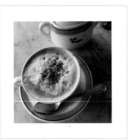
bjenkins83prime/Instagram

heyitsyaya/Instagram

nicekicks/Instagram

#coffeetime #coffeelife #coffeeporn #studio365challenge

♥ ♥ ♥ ♡ ♡ # AFTERNOON TEA

Recently there's been an afternoon tea renaissance — and it makes so much sense. Whether you're at the Ritz or a local teashop, there is something decadent about crust-less cucumber sandwiches and spending time with loved ones!

Focus

- Capture every detail; every layer is an important part of the experience.
- A few cake-to-mouth shots are imperative!
- And don't forget to lift that pinky when supping your Earl Grey!

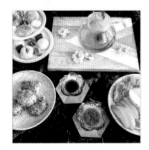
emilysdaily_gram/Instagram

e_peirce/Instagram

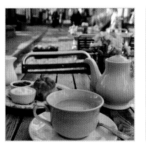
omyengland/Instagram

karen.h.91/Instagram

#afternoontea #hightea #tearoom #studio365challenge

WHAT'S IN MY FRIDGE? ♥♥♡♡♡

Do you ever find yourself repeatedly fridge-peeking only to find there's nothing to eat? Do you find a well-stocked fridge an absolute wonder to behold? You are not alone! What does your fridge say about you?

Focus

- Have a 'fridge-off' with friends and see whose is the most well-stocked.
- Organise contents into colours for the most striking results.
- Keep the contents dead centre for an all-encompassing focus.

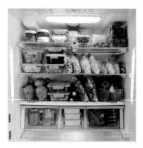
hellonutritarian/Instagram

fridgecoaster/Instagram

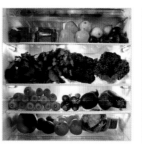
womenshealthaus/Instagram

mountainmagick/Instagram

#whatsinyourfridge #fridgegoals #fridgeworthy #studio365challenge

ICONIC RECREATION

Have a favourite album cover or iconic fashion shoot photo? Why not have a go at recreating them with friends or family. Whatever the results, you are sure to have fun!

Focus

- This is something you can make as complex or as simple as you like.
- What about a favourite film series?
- Or a favourite book?

paulinotschka/Instagram

nymess/Instagram

agf.97/Instagram

jwbaughphoto/Instagram

#iconicrecreation #myversion #starringme #studio365challenge

LOOK BOOK

If you're a dedicated follower of fashion, you're sure to shop the latest trends each season. Show your style to your followers with a look book of your favourite pieces and outfits.

Focus

- Shoot on location: head to the beach during the summer, and somewhere cosy in winter.
- Show the big picture so your followers can see the whole outfit...
- ... and focus on the detail with close-ups.

chloe_t/Instagram

a_southerndrawl/Instagram

seekinpleasure/Instagram

syakirapamayo/Instagram

#lookbook #aw2017 #stealmystyle #studio365challenge

HABITS

Whether it's a bad habit or something that makes you smile, try to capture a candid photo of a loved one and their daily routines.

Focus

- Turn the camera on yourself next time you catch yourself in a habit.
- Demonstrate a bad habit artistically – like a snap of your watch if you're always late!
- If your friends and family don't have any bad habits, why not try catching your pets displaying theirs.

lyndaschwob/Instagram

hannahshabits/Instagram

monicacansmile/Instagram

icecreamgolden/Instagram

#habit #drivesmecrazy #badhabit #studio365challenge

A LITTLE NOTE

Everyone leaves notes. Whether it's for a colleague, a message of love or luck or a note left by a child, these little moments are worth preserving with a photograph.

Focus

- If the note relates to something, include it in the background.
- Have you spotted notes out and about? Photograph them!
- If you've left a note for someone, take a snap too.

jehanson95/Instagram

emiliemellemgaard/Instagram

lj0320kimo/Instagram

patriciaiizquierdo/Instagram

#alittlenote #postit #message #studio365challenge

♥ ♥ ♥ ♥ ♡ YOLO

What makes your heart race? You only live once, so go out there and have adventures – but make sure to take some photos to share with your followers!

Focus

- If you're an extreme sport junkie invest in a Go Pro and show the action!
- YOLO isn't always about taking risks, show your followers what makes your life amazing.
- You could use this hashtag when you're treating yourself, too! After all, you do only live once!

onparamon/Instagram

jopielee/Instagram

goprommunity/Instagram

lollyg1rl/Instagram

#yolo #extremesport #treatyoself #studio365challenge

JOURNAL LOVE

Whether you're a creative journal fan, or more of a glam planner, Instagram® is a great place for you to show off your gorgeous organisation systems. Swoon!

Focus

- Show the stages you go through to complete your gorgeous monthly layouts.
- Share photos of your stationery stash: from washi tape and stickers to the pens you use.
- Try out different lettering styles and share with your followers to give them inspiration.

nanaplans/Instagram

yuzustudies/Instagram

svphvx/Instagram

vivluvstoplan/Instagram

#journallove #bujo #glamplanner #studio365challenge

LIVE MUSIC

Whether you're at the front of a huge gig or enjoying a band at your local pub, capturing the magic of a live music performance can be tricky. Check your camera settings beforehand and be prepared to take lots of shots for one good one!

Focus

- Take a mix of close-ups of band members, and full stage shots.
- Stage lighting can be used to your advantage. Try to capture something dramatic!
- Avoid using the flash – this can be distracting to the band and fans!

bannersmusic/Instagram danilodauriafoto/Instagram giacomo_hide/Instagram luniquebasel/Instagram

#livemusic #rockthemic #gigphotography #studio365challenge

GOING GREEN

We're all doing our little bit to save the planet by recycling more, taking public transport or eating less meat. Make a pledge to do something extra and share your efforts with your followers. You might just inspire someone else to make a change, too!

Focus

- Make something out of your rubbish and share the results!
- Create step-by-step photos for a green DIY such as making your own face scrub.
- Get green fingered and grow your own vegetables – share the fruits of your labours with your fans.

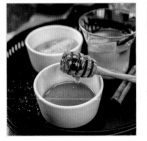

thegardensmallholder/Instagram mktsvenice/Instagram lifeisfullofgoodies/Instagram ambreblends/Instagram

#goinggreen #ecofriendly #savetheplanet #studio365challenge

FOODSTAGRAM

Have you noticed that people love sharing photos of their food? Take your food snaps to the next level and turn them into works of art. You'll have your follower's tummies rumbling in no time!

Focus

- If you're shooting a meal you've prepared think about presentation...
- ... coordinate colours of foods, dishes and backgrounds and mix up your cutting techniques.
- Take shots along the way – from ingredients to preparation to the beautiful finished dish.

themelbourneurbanite/Instagram

yogimurmurs/Instagram

sin ana/Instagram

old town review guys/Instagram

#foodstagram #icookedit #homecookedmeal #studio365challenge

FRIENDSHIP

They make the world a better place and moments of true friendship make beautiful photos that you'll want to keep forever.

Focus

- Capture innocent moments of friendship between children.
- Been friends forever? Why not recreate some of your old photos?
- Show off the weird quirks of your friendship in a picture!

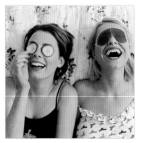

tushingole/Instagram

coleyyyyy_xoxo/Instagram

laruselle/Instagram

pandering_to_boys/Instagram

#friendship #BFFs #friendsforever #studio365challenge

♥ ♥ ♥ ♥ ♡ EMOJI

Sometimes life imitates art or at least it sometimes imitates emoji. Capture moments that reflect a particular emoji or a feeling and share this fun post with your followers.

Focus

- If you've got a favourite emoji, set out to recreate it in photo form!
- Capture someone's facial expressions and match it up to one of the emoji characters.
- Why not extend this challenge and recreate the emoji keyboard?

itsme.suzi/Instagram

365_today/Instagram

jilly_ding/Instagram

livinloftlife/Instagram

#emoji #emojiirl #feelingemojinal #studio365challenge

HOME TO ME

Home is where the heart is. Show your followers where your heart lies and share some images that show off what home is to you.

Focus

- Think beyond place; try to capture a moment that makes your home, home.
- Share a portrait of those that make you feel at home wherever you are.
- Everyone has something quirky lurking in their home. Share your homely quirks!

kinia_malinowska/Instagram

sonjacannon/Instagram

lifeingrace/Instagram

zellypepper/Instagram

#hometome #homeiswheretheheartis #thisishome #studio365challenge

♥♥♡♡♡ # HAPPY BIRTHDAY TO YOU

One thing you can be sure of, birthdays come round every year and are deserving of a bit of insta-immortalisation.

Focus

- With friends and family, you will have many opportunities to add to your birthday feed.
- You could theme your images to reflect the style of the birthday girl/boy.
- Create a montage to capture how the celebrations went down.

shopthebluehydrangea/Instagram

eventswithblooms/Instagram

allet schicke/Instagram

healthychefsteph/Instagram

#birthday #birthdayoutfit #birthdayfun #studio365challenge

SAY CHEEEEEEESE

Okay, so this task is regarding all things synonymous with everyone's favourite savoury bite: cheese! We're talking big smiles, blocks of cheese, gooey cheese, flaky cheese, smooth cheese, quince jelly...

Focus

- Extra cheesy grins are a must as are bounteous amounts of cheese.
- Combine the two together, if you can handle all that CHEESE!
- And don't forget #nationalcheeseloversday on January the 20th.

douwe_tiemersma/Instagram

glassmartiniphotography/Instagram

theplatterqueen/Instagram

katya_nea/Instagram

#saycheese #cheeseface #cheeseboard #studio365challenge

♥ ♥ ♥ ♡ ♡ TO BE FAIR

Many of us make conscious decisions to think about the environment in the every day. If that sounds like you, take the opportunity to spread the fair trade, eco-friendly choices you make.

Focus

- It's in the clothes you wear, the food you eat, the products you use.
- There's a lot of inspiring shots out there.
- Being more aware of your daily fair trade choices may help you change the world.

fairfashion/Instagram

crown.brew/Instagram

thenewdenimproject/Instagram

nelsfinest/Instagram

#fairtrade #ecofriendly #sustainable #studio365challenge

ALL THINGS VINTAGE

We are a culture that routinely delves into the past to make the present sparkle. We love vintage stuff and it loves us.

Focus

- If you love to wear vintage then get selfie-snapping with some delectable ensembles.
- Kitsch, classic, divine – vive la vintage!
- From thrift shops to Nana's loft, there are treasures waiting for you – happy hunting!

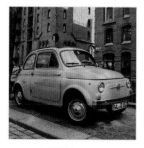

isabellath/Instagram

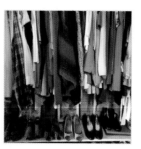

brechosempreconceito/Instagram

mooved.be/Instagram

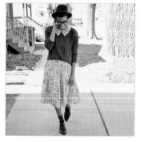

annab34r/Instagram

#vintage #vintagestyle #vintagelove #studio365challenge

SOFTY

Do you have a favourite toy and do they still have a place on your pillow as well as in your heart? Let's meet our cuddly chums!

Focus

- You could create a storyline for your oldest friend.
- Perhaps they could come on holiday with you?
- Or join you for a date to the cinema?

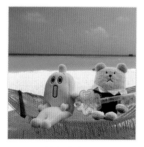

uheaaaa/Instagram

swattzz sharpe/Instagram

poptheplushie/Instagram

sircus/Instagram

#softies #softtoy #sewcute #studio365challenge

TASTEFUL TOILETS ♥♥♥♥♡

This challenge isn't about taking photos of any old toilets. Seek out unusual urinals and beautiful bathrooms and share your posh potty photography with your followers.

Focus

- Restaurants or boutique shops often have pretty bathrooms.
- Toilets in unusual places are also worth sharing.
- You might want to get in and out quickly, but take a few moments to compose your photo.

simonpherring/Instagram

abbatts/Instagram

saraha1200/Instagram

m_overmeer/Instagram

#tastefultoilet #unusualloo #toilethumour #studio365challenge

ALL THAT GLISTENS

Whether you're drenched in diamonds or rocking a bit of costume jewellery, the bejewelled accessories we choose to wear can say a lot about ourselves. Get up close and show the beauty of those jewels!

Focus

- Create a portrait series featuring the pieces of jewellery friends and family wear every day.
- Show off your collection in a fun and unique way.
- Get up close and use clever lighting to make the jewellery sparkle!

curtindesigns/Instagram

speakeasyjewels/Instagram

seasonsandstories/Instagram

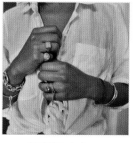

danielladraper/Instagram

#allthatglistens #jewellery #customjewellery #studio365challenge

WINDOW SHOPPING ❤❤♡♡♡

We've all spent time gazing longingly at the elaborate window displays of our favourite shops, just imagining the shopping spree we'd take. Capture your favourite window displays and, hey, it could also act as a wish list for your birthday!

Focus

- Next time you're somewhere different, spend some time exploring the local high street.
- Look for pretty shop fronts and capture the whole window, or just a detail...
- ... but be aware of glare and reflections. Avoid them, or use them to your advantage!

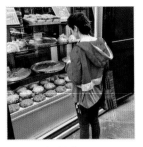
evde_yoklar/Instagram

toconoco/Instagram

shopwindowstyle/Instagram

gracefulmemories/Instagram

#windowshopping #wishlist #shopfront #studio365challenge

WHERE I GREW UP

The places we live, visit and play as kids have a huge effect on the person we grow up to be. Revisit your childhood haunts with your camera and capture some nostalgia.

Focus

- Visit your family home, a grandparent's house or a much loved park...
- ... if you've moved away plan a trip to your old stomping ground.
- If you've got old photos of specific places, try to recreate them.

ashleyraymond/Instagram

goodwill gone glam/Instagram

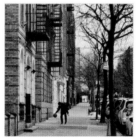
rc_footprints/Instagram

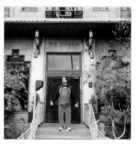
theplantlife8/Instagram

#whereigrewup #childhood #oldhome #studio365challenge

ONE THING FROM EVERY ROOM ♥♥♡♡♡

Give your followers an insight into your life by photographing one thing from every room in your home.

Focus

- Get in close and find those often overlooked details.
- Share your favourite objects with your followers.
- Show the object in situ or isolate each object on a white background.

ingahaarr/Instagram harrybeau_and_i/Instagram paradiset1 /Instagram concretejunglede/Instagram

#onething #myhomeinsixobjects #housetour #studio365challenge

♥ ♥ ♡ ♡ ♡

GEEK OUT

Everyone can be geeky at times. Whether you're geeking out about the latest comic book film, or you're passionate about sports cars, take a photo to show off your geekiness and be proud!

Focus

- If you're attending a specialist event, document it as a story.
- Show off any collections you have, piece by piece.
- Secret geek? Let your followers in on your secret!

mpoppins_cosplay/Instagram

designatelierarticle/Instagram

point.gym.kitchen/Instagram

guitarsandwheels/Instagram

#geekout #imageek #geekalert #studio365challenge

NAIL ART

♥♥♥♡♡

Whether you're a dab hand with the nail polish or you enjoy getting a manicure, take a photo of your latest #nailart creation.

Focus

- If you're not into nail polish, photograph a friend's hands for this challenge.
- Focus on the hands, but think about the background and the pose.
- If it's something complex, document the process with step-by-step photos.

aki_ingk/Instagram

lecachesalonspa/Instagram

10perfectnailshk/Instagram

matreshka_as/Instagram

#nailart #manicure #nailpolish #studio365challenge

 GET JUICING

If you're into the juicing trend, turn that trend into a photograph! Capture the beautiful colours and mixtures of your daily juicing routine.

Focus

- This would be perfect for a before and after photo...
- ... take a photo of what you're putting into the blender...
- ... and then snap a picture of your juice before you enjoy it.

drink.the.rainbow/Instagram

lifealchemyhealth/Instagram

rainbowplantlife/Instagram

mietisst/Instagram

#getjuicing #fruitblend #willitblend #studio365challenge

THE PERSONAL TOUCH

Next time you're visiting a friend's house, look for the personal touches in their home that show off their own style and personality and photograph it for a portrait without a subject!

Focus

- Be eagle eyed and look for little details in their décor.
- From the art on their walls to the books on their shelves, everything has a story to tell...
- ... you might even find a bit of your friend's personality in the food or drinks they serve you!

ebruzulfikaroglu/Instagram jahddesign/Instagram flwr.studio/Instagram alifeunfolding/Instagram

#personaltouch #objectportrait #personaldécor #studio365challenge

♥ ♥ ♥ ♡ ♡ # MUSEUM MOGUL

Next time you're visiting a museum or gallery (and you're allowed to take photos!), share the most interesting objects with your followers.

Focus

- Try to share the story of an object through the photo's composition.
- If there's anything HUGE, show the scale by including a person in the photo.
- Or for anything tiny, use your zoom lens to show off any intricate details.

sam5967/Instagram

cyndytea/Instagram

go2as/Instagram

joy_crack/Instagram

#museummogul #ancient #workofart #studio365challenge

BINGE WATCHER

With such easy access to box sets it's easy to binge our favourite TV shows. Share your TV binge habits with your followers – you might even connect with fellow fans!

Focus

- Show your followers what the perfect binge night-in looks like for you.
- Share your reactions to key moments in the series with your followers.
- If you're a super fan go the extra mile and host a themed viewing party – with photos, of course.

craigy_babeh/Instagram

cabralmvs/Instagram

fullhouseofroyals/Instagram

ferynlouise/Instagram

#bingewatcher #favouriteshow #stayingin #studio365challenge

♥♥♥♡♡ # MOOD BOARD

Create a collage and share a mood board of photographs. This could be to inspire your fashion choices, show off your aesthetic or to help plan an upcoming event.

Focus

- Snap photos of things that will inspire your mood board...
- ... and then use a layout app to place them together...
- ... think carefully about the size and placement of each photo for a harmonious mood board.

jasminedowling/Instagram

liefhebberij/Instagram

shopcorn/Instagram

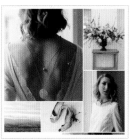
emmas_hj/Instagram

#moodboard #aesthetic #favouritethings #studio365challenge

FLAMINGO-GO

The brightest birds at the bird-park; flamingos are eccentric, flamboyant and bang on trend. Be inspired by these brighter-than-life birds in your photography.

Focus

- How many flamingo-themed style items can you find? Snap a photo of every flamingo you spot.
- If you can, visit the pink-tinged wonders in person and take some colourful photos.
- Be inspired by the pink tones and create a pink feed for a week.

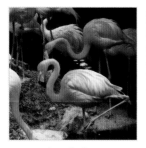

serenityangelart/Instagram

littlemooshoo/Instagram

king_soniya/Instagram

lillakakaofugl/Instagram

#flamingo #flamingostyle #flamingolove #studio365challenge

MAKEUP

For some, makeup is far more than just part of a morning routine; it is an active obsession, a preoccupation, and a passion! If you love makeup, share some photo love.

Focus

- Take a number of photos showing a makeup look step-by-step.
- You could focus in on your makeup bag and take some gorgeous product shots.
- If you're showing off a gorgeous look take two photos, one with your eyes closed and one open!

zuzanahumajova/Instagram

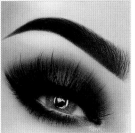

_sarah_sores/Instagram

chelseabeautyspy/Instagram

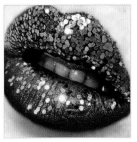

margarita_mua_lips/Instagram

#makeupaddict #makeupgeek #getthelook #studio365challenge

HANDMADE

In a world of mass-produced, mass-consumed items, it's a delight to have things that are made by hand in our lives and homes. Share your favourite home-spun items with your followers.

Focus

- Create a photo series of your favourite handmade items.
- If you or someone you know is a crafter, document the process through photographs.
- Make sure that your shots are well lit to show off the item in the best possible light.

modanostra2a/Instagram

lys_stitches/Instagram

by_karimova_kzn/Instagram

holzschreiber/Instagram

#handmade #imadeit #crafter #studio365challenge

♥♥♥♥♡ GIRL GAZE

This photo trend focuses on the way girls see the world through photography. Why not ask your nearest and dearest female friends to help you create an image that represents their views right now?

Focus

- You could break out of traditional stereotypes and cultural projections.
- Try to tell stories through your camera to express a different point of view.
- Alternatively, create a series of photos through the eyes of a range of people.

satellitejune/Instagram

adelinelamy/Instagram

rndyrenaldy/Instagram

overcomerbaby/Instagram

#girlgaze #girlgazeproject #conceptualphotography #studio365challenge

TEN THINGS

You can add up to ten photos in one Instagram post. Select ten things on a theme, photograph them and then share with your followers.

Focus

- The opportunities are endless: ten things in my room; ten things I can't live without...
- ... or perhaps try portraits: ten people I love; ten selfies; ten new friends...
- ... or photograph the same thing ten times, each time showing a different angle or focus.

lotteleemoeller/Instagram

loveclaudiab/Instagram

surabhijain56/Instagram

cutecatsco/Instagram

#tenthings #tenphotos #favouritethings #studio365challenge

 # LIVE THE UNICORN LIFE

If you love things bright, fluffy and sparkly, you're probably already living the unicorn life. It's bang on trend and is sure to put a smile on your face. Share your unicorn moments.

Focus

- Channel your inner unicorn and dress in bright colours and take an #OOTD photo.
- Look out for colours, particularly pink, during your day to photograph.
- The shops are full of unicorns at the moment; snap some fun unicorn merch.

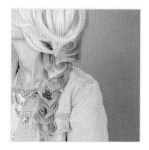
mariannetaylor/Instagram

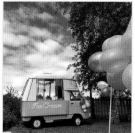
icebaby icecreamvan/Instagram

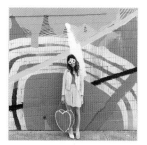
sophlog/Instagram

frends/Instagram

#myunicornlife #colourful #magical #studio365challenge

SOLO PARKING

This challenge is not just for car lovers. The #soloparking hashtag features interesting shots of cars parked alone. From the luxurious to the abandoned, look out for those lonely vehicles.

Focus

- Look for an interesting composition. A contrasting background can really make a shot pop.
- This is a great way to show off your new wheels – drive somewhere gorgeous and take a snap.
- Abandoned and dilapidated vehicles can make great statement photos.

kylieroux/Instagram

angelacoomey/Instagram

nycars/Instagram

winkybe/Instagram

#soloparking #abandonedcar #greatparking #studio365challenge

♥ ♥ ♥ ♥ ♡ COME FLY WITH ME

Next time you take to the air, don't miss the photo opportunities. Only use your phone or camera if your flight allows it!

Focus

- Take a photo of the airplane from the terminal or the tarmac.
- If you're awaiting a flight, see if you can capture any landings or take-offs.
- Upgrade luxury? Make your followers jealous with photos on-board.

prettyflyforarampguy/Instagram ilnoi/Instagram stef.g.k/Instagram janna agababyan/Instagram

#comeflywithme #airplane #flying #studio365challenge

RIGHT NOW

Pick up your camera right now, as you're reading and get ready to capture some quick-fire photos, wherever you are, using the prompts below.

Take a photo of something or someone...

☐ ... I love

☐ ... I am avoiding

☐ ... beautiful

☐ ... I want to eat

☐ ... that makes me happy

☐ ... I need to do

☐ ... that is fun

☐ ... that is inspiring

☐ ... that makes me sad

☐ ... that I am excited about

☐ ... that is worrying

☐ ... that is interesting

senhepkalbimdesin/Instagram

littlenivimus/Instagram

artizaza/Instagram

nick_waddington/Instagram

#rightnow #somethingilove #somethingbeautiful #studio365challenge

 ♥♥♡♡♡ # DRESSING TABLE

Dressing tables, jewellery stands and cosmetic stashes can show a lot about our true selves. After all it's the place we come to tame our bed head and to make ourselves presentable! Share elements of your dressing area with your fans.

Focus

- You could share a photo showing the whole area or dressing table. Make sure it's tidy!
- Alternatively focus on small details in a series of photos; from favourite products to beloved jewellery.
- Go one step further and photograph yourself at your dressing table. Mirror selfie!

rosey malone2/Instagram

highfieldwildrose/Instagram

makeupbymissjojo /Instagram

rockmystyleblog/Instagram

#dressingtable #lotionsandpotions #getready #studio365challenge

MY WORKSPACE

From students and office workers to home chefs, crafters and shed enthusiasts, we all have a space dedicated to the work we do. Take a photo to give your viewers a glimpse into your workspace.

Focus

- Take a shot showing the whole space, and then a series of detailed shots.
- If you have a work in progress, keep that in your workspace for your photograph.
- You could take a before (tidy) and after (messy) photo.

saun24/Instagram

medandreord/Instagram

bsandfoss/Instagram

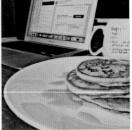

paigelizabeth._/Instagram

#myworkspace #workinprogress #officelife #studio365challenge

 # PET SHAMING

If you've got a mischievous pet, there's no doubt it sometimes misbehaves itself. Next time your pet steps out of line, set up a hilarious pet shaming photograph to share with your fans.

Focus

- Handwrite a sign and place in shot with your pet.
- If you can, capture the moment before you clean up.
- Try to capture the expression on your pet's face. Is it remorseful, guilty, or completely nonchalant?

my_cav_mycharlie/Instagram pekkapu/Instagram leigha_bobeah/Instagram jessklein18/Instagram

#petshaming #catshaming #dogshaming #studio365challenge

CHOCAHOLIC

If you have a sweet tooth, you'll know that chocolate doesn't just come in bars. Look out for sumptuous chocolate goodness and marvellous cake creations.

Focus

- Look in windows of cafes and patisseries: you're bound to spot a work of chocolate-art.
- Make your photo look good enough to eat with filters and colour editing.
- If you're not a chocaholic show off your guilty food pleasure.

grubzon/Instagram

dekookpot/Instagram

roseandbasil/Instagram

desserts.co/Instagram

#chocaholic #delicious #ilovechocolate #studio365challenge

POLAROID

Polaroid photos were the instant photos of a previous era. If you can get your hands on a polaroid camera (and film) you can play around with this nostalgic form of photography, and then share it digitally!

Focus

- Polaroid films come in a wide range: from black and white to colour tints and bright frames.
- Use your polaroid film sparingly. You only get a limited number of shots, make them count!
- Combine polaroid photos with modern, digital technology.

cedgrenbawden/Instagram

towoprass/Instagram

gierja/Instagram

klapi/Instagram

#polaroid #analogue #photoinaphoto #studio365challenge

GAMES NIGHT

Whether you love playing board games or you're more of a computer gamer, set up a games night with your friends and capture the highs, lows and all the action.

Focus

- Many board games are beautifully designed: capture the small details.
- Wait for the win and get your camera ready to photograph the victors.
- Update your followers as you play with an insight into what's in your hand – but no cheating!

bestintest/Instagram

laurahayes4/Instagram

westamber4/Instagram

queenofspadesatstop17/Instagram

#gamesnight #boardgame #forthewin #studio365challenge

CLOCKS

Take your time to photograph... time! Look out for interesting clocks, from antique carriage clocks to enormous station clocks.

Focus

- Town clocks are coming to a halt, or disappearing forever. Look out for characterful town clocks.
- If you're able to get a view of the movement, take a photo. The cogs are just as interesting as the face.
- For an extra challenge, aim to take a photo of a clock at the same time every day.

carmelitamou/Instagram

museumoftime/Instagram

swm71/Instagram

nicocurio/Instagram

#clocks #whatsthetime #itsinstatime #studio365challenge

LONDON, PARIS, MILAN

These may be the most fashionable cities in Europe, but there are moments of high fashion to be found everywhere. Seek out country couture and suburban style with your camera.

Focus

- Undertake some street photography. If you flatter a subject with a compliment about their style, they may allow you to take their portrait.
- Look for contrasts of high fashion vs. traditional or boring.
- Think beyond clothes and take photos of fashionable looking shops, cafes or bars.

fashion.voyage/Instagram

quackanddirk/Instagram

yaasomuahdaily/Instagram

blake_martin/Instagram

#londonparismilan #localfashion #countrycouture #studio365challenge

♥ ♥ ♡ ♡ ♡ # MILKSHAKES

Have you finally caved into your cravings and decided that today's the day that you're going to treat yourself to a milkshake? Well, don't forget your camera!

Focus

- Share your favourite milkshake with your fans.
- Make your own milkshake at home and share the recipe and the process with your fans.
- Grab a milkshake with your friends and take a selfie of you all drinking your shakes.

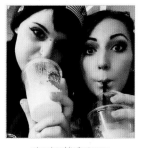
miss_ninawhite/Instagram

goodeatzco/Instagram

foooodieee/Instagram

mimisbakehouse/Instagram

#milkshake #freakshake #cakeshake #studio365challenge

AUTO LIFESTYLE

If you're a car lover, keep your eyes peeled for insta-worthy automobiles. If you've got a favourite car or manufacturer, make it a rule to always snap a photo when you spot one.

Focus

- Look out for vintage vehicle events for the opportunity to take some truly stunning photos.
- Cars can look beautiful in the rain. Next time the heavens open, go car spotting!
- Head out at night to capture some light trails from the car's headlights.

petrolheads_uae/Instagram

auto_drives/Instagram

julia.dxb/Instagram

vomos/Instagram

#autolifestyle #car #luxurycars #studio365challenge

 # #CAKESTAGRAM

Do you love cake? Do you lay awake at night thinking of all the wonderful cakes out there just waiting to be eaten? Well you're not the only one. So grab your camera and prepare to lead your fellow cakeaholics on a cake-eating bonanza

Focus

- Share seven days of cake with your followers.
- Invite friends and family over for a bake off and take plenty of photos.
- If you love to bake, share your process as a series of step-by-step photos.

ohnina.co/Instagram

marianssen/Instagram

heartandcake/Instagram

mamas.cupcakery/Instagram

#cakestagram #cake #cupcakes #studio365challenge

PIN BADGE STYLE

Badges are a great way to show off your personal style. Show off brooches and pins, badges and buttons with this fun photo challenge.

Focus

- Whether you're highlighting your personal style or someone else's get in close to show the detail.
- Who says brooches are old fashioned? Dig out your grandma's costume jewellery, shine it up and get photographing.
- If you enjoy street photography, look out for anyone rocking pins on their bags or jackets and ask if you can take a snap.

littleleftylou_shop/Instagram

malice_in_wonderland_x/Instagram

newfieldchress/Instagram

evintique/Instagram

#pinbadgestyle #badgesandbuttons #brooches #studio365challenge

MAGPIE

Go for a photo walk and channel your inner magpie. Photograph anything that's shiny. Bonus points if you manage to capture your own reflection.

Focus

- Look for unusual places to catch your reflection, such as a shiny button or even a puddle.
- Keep your eye out for anything the sun is reflecting off. It'll be shiny!
- Metallic and glass surfaces in close-up can make interesting pictures. Get your followers to guess what it is!

goapebracknell/Instagram

bigbadwolfster/Instagram

luciennejewellery/Instagram

fkn_pat_glass/Instagram

#magpieshiny #shinythings #reflection #studio365challenge

FIRE

❤ ❤ ❤ ❤ ♡

Ever since man created fire, we've been mesmerised by it. Capture those flames whether it's a roaring log fire, a campfire or the flame on a candle. Make sure to undertake all necessary precautions when you're near an open flame.

Focus

- Capture a fire after sunset for a beacon in the dark night.
- Create a sense of cosiness and photograph props or subjects in the foreground of the fire.
- Use the fire as the light source for a dramatic portrait.

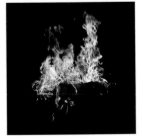

iamluckymercy/Instagram cogdon_photography/Instagram pseagger/Instagram josedewa_dts/Instagram

#fire #flame #campfire #studio365challenge

 PICTURE FRAMES

Use your account to celebrate the pictures on your physical wall as well as your digital one. Share snaps of your framed photos and artworks.

Focus

- Show off your display skills with a photo wall.
- Or focus on the frames, showing any pretty or ornate details.
- This is a great way to share #TBT photos that you are unable to scan.

vintagebayhitchin/Instagram

kos.home/Instagram

make.me.young/Instagram

matthew oliver weddings/Instagram

#pictureframe #photowall #ondisplay #studio365challenge

PAPER CRAFT

Whether you're an origami expert, skilled at paper cutting or just pretty good at folding paper napkins, create a piece of paper artwork and then photograph to share.

Focus

- Use lighting and angles to 'bring the paper to life'. Experiment: you might just be amazed.
- If you're not feeling creative find some pretty papers and create a flat lay.
- Get crafty with the kids and challenge them to create something using just paper. Photograph the final product, and the fun process.

kirigamifun/Instagram

wohnprojekt/Instagram

cornflowerandcalico/Instagram

elisacanaglia/Instagram

#papercraft #origami #prettypaper #studio365challenge

♥ ♥ ♥ ♥ ♡ DOGGY PLAYTIME

Who doesn't love pictures of dogs in fancy dress? Dress your pet up as characters from your three favourite films and challenge your followers to guess which characters they are.

Focus

- You need three things for this challenge; a dog, a camera and a bunch of fancy dress clothes to dress your dog up in.
- Be quick with the camera, your dog won't sit still forever.
- Don't do anything that distresses your dog.

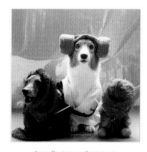

dogsofInstagram/Instagram

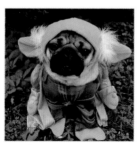

pugthedougg/Instagram

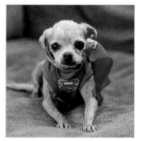

dogsofInstagram/Instagram

dogsofInstagram/Instagram

#dogsofinstagram #dogcostumes #petcostumes #studio365challenge

INDULGE

What's your guilty food pleasure? Next time the cravings hit and you cave into temptation, share your indulgent moment with your followers. No need to feel guilty, no one's perfect!

Focus

- Snap a photo of yourself indulging in a tasty treat.
- Play with angles, lighting and filters to make the food look as good as it tastes.
- If you are feeling the guilt, follow up with a post-treat photo.

adwahs/Instagram

papaya sunshine/Instagram

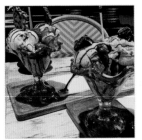

foodie.sydney/Instagram

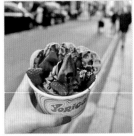

yoricamoments/Instagram

#indulge #yummy #foodie #studio365challenge

SANDWICH LOVER

Nothing beats a good sandwich, and everyone has a different idea of what makes the perfect sarnie. Whip up your own favourite and share your creation with your followers.

Focus

- Create a step-by-step. It's all about the preparation.
- Share a week's worth of sandwich creations with your followers. Be bold and experiment to find a new flavour.
- Got a favourite lunch spot that just makes the best subs and sandwiches? Share your lunch experience.

ikidanenippon_hk/Instagram

luce.ica/Instagram

janespantry/Instagram

manuelawilms/Instagram

#sandwichlover #BLT #tasty #studio365challenge

HOMESICK

Whether you're living in a different country, away for the weekend or you're longing for the home you grew up in, we all experience homesickness at times. Photograph what's making you miss home.

Focus

- Food can be one of the most evocative memories of home. Share your favourite snacks from home.
- This is a great way to showcase a #TBT photo. Share a photo of a place you miss.
- Alternatively show how you're combatting your homesickness.

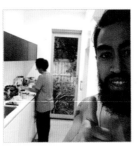

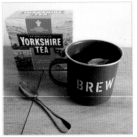

sitinratiqah/Instagram paeahitamati/Instagram tim.abt/Instagram robschnepp/Instagram

#homesick #homewardbound #homeiswheretheheartis #studio365challenge

BABY ANIMALS

If you share a photo of a baby animal, you're pretty much guaranteed likes. Nothing makes people coo more than a cute photo of little fluffy creature.

Focus

- If you're lucky enough to have a baby pet, share it's milestones with your followers.
- Head out in spring to capture the new life around you, from lambs and ducklings to cubs and chicks.
- Use a zoom lens rather than getting close to a wild animal. You don't want to scare the baby, or upset Mama!

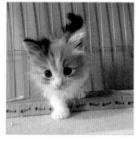
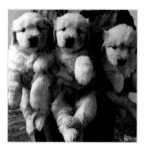

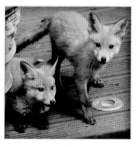

jiochama4378/Instagram
noelle_the_golden/Instagram
gumby_thecat/Instagram
paulgwhite123/Instagram

#babyanimal #toocute #sofluffy #studio365challenge

NAMES

Names are an important part of identity and can be written almost anywhere. Whether it's your name, a loved one or a stranger, share a name photo with your followers.

Focus

- Look for your own name when you're out and about and capture a photo every time you spot it.
- At a wedding or fancy dinner party? Share a snap of your place name.
- Share any trinkets you have that are personalised, such as necklaces.

mosaic60/Instagram

almeidadyane/Instagram

lovebird_events/Instagram

thequesnelles/Instagram

#names #whatsinaname #namestagram #studio365challenge

DANCING

Whether they're a trained dancer or they just love to boogie, people lose their inhibitions when they dance and that makes for some great photos.

Focus

- Get into the middle of the dance floor for some amazing action shots.
- Put on some music and ask your friends to throw their best moves.
- Head to a professional dance show to capture some dramatic, elegant shots.

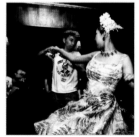
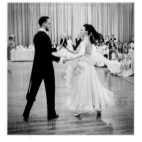

danceologymx/Instagram yassinkouko/Instagram madame_murasaki/Instagram mirceasiandreeadansatori/Instagram

#dancing #throwshapes #dancewithme #studio365challenge

COMMUNITY

Celebrate your local community and the people that are a part of it with a series of candid photographs.

Focus

- If you're part of a large community, take your camera along to your next meet-up.
- Attend local events such as fetes to get a sense of your local community.
- Capture those kind moments that make a group a community.

hampsteadheathmaria2/Instagram

healthycasscreations/Instagram

sarahroe1/Instagram

taybfit.31/Instagram

#community #local #neighbours #studio365challenge

TRADITIONS

Do you have any family or cultural traditions that you keep up every year? Share your favourite traditions with your followers and add a caption to explain what's going on.

Focus

- If you belong to an interesting culture, share an element such as traditional dress.
- Do you have any silly birthday or Christmas traditions? Take a photo of the tradition in action.
- If you're taking part in a traditional event, share photos throughout.

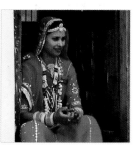

dimpalsharma/Instagram

traveling_grace_fully/Instagram

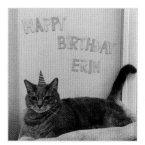

tpersia/Instagram

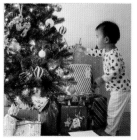

maynalu/Instagram

#traditions #traditionaldress #birthdaytradition #studio365challenge

BICYCLES

It's the greenest way to get around so it's no wonder we're seeing more and more bicycles in our towns, cities and our countryside. Whether you're a cyclist or not, snap a cool bicycle shot.

Focus

- Many cities offer bicycles to hire. Capture an urban landscape filled with bikes.
- Bicycles are pretty cool fashion accessories. Set up a shoot with a vintage bike.
- Attend a cycling race and snap the cyclists in action.

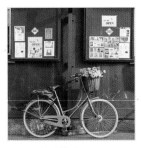
velespitbike/Instagram

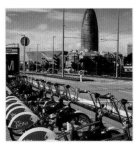
pll.sandra/Instagram

reidnewphoto/Instagram

lauraceldrans/Instagram

#bicycle #iwanttoridemybicycle #cycling #studio365challenge

 # THE FUN OF THE FAIR

Head to a local fun fair or theme park and capture the fun, exciting atmosphere. If it's safe, take your camera on a ride with you.

Focus

- For rides in the sky, angle your shot so it looks super high.
- Capture those vintage details on rides such as the carousel.
- On a sunny day aim for a silhouette shot of a rollercoaster. Capture the curves, and the fun.

sonjacannon/Instagram maik scherzer/Instagram megumi3811/Instagram thiagovec/Instagram

#funofthefair #fairground #lifeisarollercoaster #studio365challenge

HOW DO YOU LIKE YOUR EGGS? ♥♥♥♥♡

We all have a preference on how we take our eggs. Share your favourite egg recipes, whether it's breakfast, lunch or dinner.

Focus

- Share your step-by-step, from cracking the egg to the finished dish.
- Challenge yourself to cook an egg in a different way; photograph the results.
- Boost the colour of the yolk with a filter.

hfitness95/Instagram

charissac/Instagram

healthy.happy.laura.x/Instagram

emmasfood/Instagram

#howdoyoulikeyoureggs #fried #sunnysideup #studio365challenge

DUVET DAYS

Whether you're off work feeling unwell, or just taking a duvet day to relax and refresh, share your ultimate lazy (or sick) day routine.

Focus

- Duvets, comfy pyjamas, snacks and a brilliantly terrible movie are a must for this challenge.
- Share a sofa selfie – as long as your camera is within reach. On duvet days you shouldn't have to move... too much.
- Channel your inner child and build a fort using blankets. Give your followers a tour of your castle.

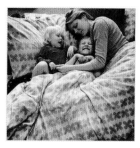
cblakey/Instagram

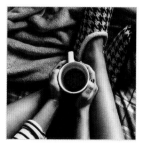
homeyysslippers/Instagram

roseandweston/Instagram

alisonjewett/Instagram

#duvetday #sickday #blanketfort #studio365challenge

CHARITY

♥ ♥ ♥ ♥ ♡

We all need to do our bit for charity. Choose a cause that's close to your heart, get involved and share some photos. Whether you're donating clothes, volunteering or taking part in a fun run, you may help to raise awareness with your followers.

Focus

- Spend a week wearing charity shop #OOTD fashion to inspire your followers.
- If you're taking part in a run, share your training routine in the lead up.
- Volunteer for a good cause and share a #volunteerwefie

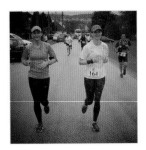

monikavaski/Instagram

elaineroseford/Instagram

the_live_well_community/Instagram

floralroseprincess/Instagram

#charity #charityshop #volunteerteam #studio365challenge

 FESTIVAL

Head to a local festival or celebration event and capture the joyful moments of the festivities. This is a great opportunity for candid pictures and street photography.

Focus

- Whether it's a music festival or a local fete, capture the vibe of the day.
- Look out for amazing outfits and costumes and take some portraits.
- As always, look out for small details to share with your followers.

ilmingtonmorris/Instagram

pale.blue.iris/Instagram

vijeesh.vimalan/Instagram

yolandadance/Instagram

#festival #localfete #festivalfashion #studio365challenge

#DOUBLEDENIM

Denim is the staple, long-stay of the fashion world. It goes with anything, it saves any look and it never gets old. Rejoice, in the famous fabric, perfect for every generation.

Focus

- Denim's versatility is what makes it so popular so ensure you reflect this in your photo.
- Colourful, vibrant, or monochrome subtlety, there is always a place for denim.
- It can be the main centrepiece of the frame, or melt effortlessly into the story.

jamiegenevieve/Instagram

ironcladdenim/Instagram

ezrabigar/Instagram

mommoindigo/Instagram

#denim #denimlover #doubledenim #studio365challenge

♥ ♥ ♥ ♥ ♡

HOUSE OF LAUGHS

Fancy a laugh? Want to give your followers' jawbones a good work out? Then see how many funny photos you can take in a day.

Focus

- Take a bunch of photos and add hilarious captions to them.
- Get your best friends round and see who can pull the silliest face, then get your followers to judge which one is the funniest.
- Tell a friend your favourite joke and photograph them laughing.

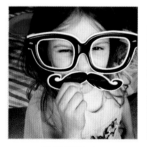
amywadz/Instagram

critommasi/Instagram

golden_freckles/Instagram

chibaus/Instagram

#houseoflaughs #funny #hilarious #studio365challenge

THE FIRST PERSON

Spend a week taking a photo of the first person you see each day. Whether it's the same family member, or a stranger (think street photography) — capture your first interaction of the day.

Focus

- If it's someone you know, grab your camera and make them smile each morning.
- Snap a photo of the first person you see after you've left the house for some candid photography practice.
- Capture a sense of mornings in your house with this fun portrait series.

kmagger/Instagram

elissgreen/Instagram

portraitsofni/Instagram

alyona_wedart/Instagram

#thefirstperson #streetstranger #goodmorning #studio365challenge

WABI-SABI

Wabi-sabi is the Zen Buddhist art of "appreciating the simple beauty in a naturally imperfect world". In Japanese wabi = "less is more" and sabi = "attentive melancholy". Capture your own interpretation of this lifestyle trend.

Focus

- Is there anything in your house that's a little chipped or broken but still beautiful?
- Appreciate the loveliness of a rainy day and set the scene for that melancholy longing.
- Think about the simple things in life that bring you satisfaction.

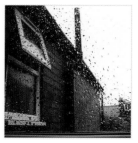

camellaslloret/Instagram frillstagram/Instagram maison_hand_fr/Instagram m.chortova/Instagram

#wabisabi #lessismore #everydaybeauty #studio365challenge

HIP HIP HOORAY

Moments of celebration, joy and delight are wonderful photos to share with your followers. Look out for hooray moments and get your camera ready.

Focus

- Next time you're at a celebration get everyone to jump for joy.
- Be prepared for the moment – the newly married couple kissing, the graduates throwing their caps, the child opening the present...
- ... make sure your camera is set up in the right mode – there are no recaps here!

eddingsvintage/Instagram abeer_kilani_photography/Instagram mommymovesalot/Instagram missjunz/Instagram

#hiphiphooray #celebration #yay #studio365challenge

PICNIC TIME

When the weather is fine, it's the perfect opportunity to dine outside. There's nothing more idealistic than a picnic. Whether your al fresco dining is Pinterest-worthy or a fun jumble, share the joy with your followers.

Focus

- Set the scene with bunting, wicker baskets and tartan blankets.
- Keep your camera close for candid moments.
- This is the perfect opportunity to snap some sumptuous food shots.

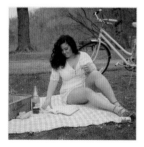

greenhoodstudio/Instagram

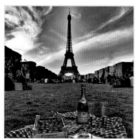

ghetiediana/Instagram

anni.f.r/Instagram

lassothemoonmia/Instagram

#picnictime #alfresco #perfectpicnic #studio365challenge

HAIR STYLES

If you're talented when it comes to styling hair, why not share your gift with the world and upload your favourite hair styles.

Focus

- Men's styles, women's styles, long hair, short hair, whatever your flair share it with your followers.
- For complex 'dos share step-by-step photos.
- Don't forget to photograph the hairstyle from different angles.

ahad_khan99/Instagram

hairdesign_by_daniela_nikola/Instagram

bridebookhair/Instagram

joeych_85/Instagram

#hairstyles #hairflair #updo #studio365challenge

WOO-HOO TATTOO

Whether you have one, want one, admire them – or not – it cannot be denied that there is a great deal of artistry and talent in many tattoos today. Art immortalised on flesh, and now on Instagram!

Focus

- It's not just about the tattoo itself but the placement on the body.
- Think about the very best ways to display the artwork.
- Be sensitive to colour in order to get the best results.

benwabesmith/Instagram

jemkatattooart/Instagram

traditionalclub/Instagram

hashtagnana/Instagram

#tattoos #tattooed #inked #studio365challenge

A-Z CHALLENGE

Look for the letters of the alphabet through your camera lens. Search every day objects and landscapes – try to find something unusual.

Focus

- Complete the alphabet in order.
- Find the letters in the natural world, or try to find them in the urban landscape.
- Finished with letters? Move on to numbers.

a.kopperude/Instagram

jfrojack/Instagram

snowyeager/Instagram

tuhraycee/Instagram

#azchallenge #letters #nature #studio365challenge

#THECOLOURRED

Spend one week focusing on taking pictures highlighting the colour red. This is a great challenge to undertake around Valentine's Day, when love, and the colour red, is all around.

Focus

- Post at least one red-themed photo a day.
- Pick up a colour card and work your way through the shades, or...
- ... focus on just one shade all week.

alexandani/Instagram

confettidesignmelb/Instagram

kreamade/Instagram

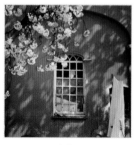

margottlm/Instagram

#thecolourred #crimson #valentine #studio365challenge

LOOK UP

Turn your lens skywards and capture a different perspective. From the night's sky to towering architecture and tree branches, you'll be amazed at the photo opportunities.

Focus

- Find a shape in the clouds.
- Take the same photo at different times of day.
- Take the same photo at different times of the year.

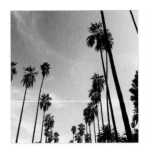

wunderkindlina/Instagram

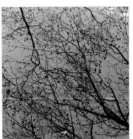

mamshk/Instagram

begadangbackpackers/Instagram

yarakawas/Instagram

#lookup #sky #clouds #studio365challenge

LOOK DOWN

Also known as #fromwhereistand this challenge is all about what's at your feet. Turn your camera down to show off where you are (or your amazing pair of shoes!).

Focus

- Spend a week showing off your fashion choices.
- Focus on nature and find something beautiful at your feet.
- Get friends involved for a group shot.

elizabethkeene/Instagram

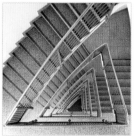

growupwiththisname/Instagram

mathildeperrin/Instagram

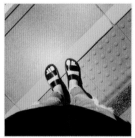

gosh b/Instagram

#lookdown #fromwhereistand #shoes #studio365challenge

PINHOLE CAMERA

If you love the grainy quality of vintage photos, this is a great challenge to try. Dig out an old pinhole camera, or make your own by punching a pinhole through a piece of cardboard and taping it over the lens of your smartphone camera.

Focus

- Create vintage-style portraits of your family.
- Add sepia or black and white filters to your photos.
- Use the pinhole camera to focus on a small area of a landscape.

cugliarimarcelo/Instagram

pironoonart/Instagram

lihmealone/Instagram

reynard84/Instagram

#pinholecamera #vintage #vignette #studio365challenge

PAST PRESENT

This project is all about showing how places, or even people, have changed over time. Use a printed photo from the past and recreate the photo in the present. Aim to show both the past, and the present in your picture.

Focus

- Use old family holiday photos.
- Create a portrait series showing the younger and older self.
- Show how your local area has changed by using old newspaper photos.

christinetran/Instagram

turalahmadov095/Instagram

yolangturgut/Instagram

sayhellotoamerica/Instagram

#pastpresent #everythingchanges #nothingchanges #studio365challenge

UPSIDE DOWN

The world looks completely different upside down. Get artistic and flip your photos to give your landscapes and portraits a new perspective.

Focus

- Instead of flipping the photos, shoot upside down.
- Use reflections in water to create something that tricks the eye.
- Make your subject look like a superhero by flipping the photo.

danjoyce/Instagram

urbanlines/Instagram

brianmkaiser/Instagram

elenaarielle/Instagram

#upsidedown #anotherangle #flipped #studio365challenge

♥ ♥ ♡ ♡ ♡ GOLDEN HOUR

The golden hour is the hour after sunrise and the hour before sunset, and is the perfect time to shoot outside. The low sun produces a soft, diffused light offering both landscapes and portraits a flattering light to shoot in.

Focus

- Travel to a local beauty spot for stunning landscape photos.
- Create a series of family portraits during golden hour.
- Still life photos of plants, flowers and wildlife will glow with the soft lighting.

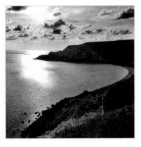
heartcyprus/Instagram

_da_n_i_/Instagram

elgato13/Instagram

nixonpiktore/Instagram

#goldenhour #perfectlighting #magichour #studio365challenge

HAND LETTERING ♥ ♥ ♥ ♥ ♥

Share your calligraphy or hand lettering skills with the world by photographing your creations. If you're not artistically inclined, find some gorgeous hand lettering to share with your followers.

Focus

- Show a work in progress from planning to completion.
- Photograph your creation and the tools used to create it.
- Share a gorgeous alphabet, spotted in an unexpected place.

shivarosedesigns/Instagram

winterbirdlettering/Instagram

k.tivs.crafts/Instagram

thefirstgradeparade/Instagram

#handlettering #calligraphy #brushlettering #studio365challenge

 # SILHOUETTE

Create an impactful and stunning image by placing your subject (whether it's a person or object) into silhouette. Place your subject in front of the light source and turn your flash off for the best results.

Focus

- Take a series of sunset silhouette photos.
- Create a portrait and try to show the character of your subject in the silhouette.
- Capture a landscape shot. Choose an interesting shape to use as your silhouette.

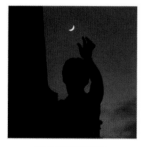

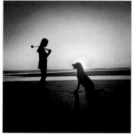

thecheloveq/Instagram labradoroftheday/Instagram do.the.math/Instagram travellilly/Instagram

#silhouette #lighting #sunset #studio365challenge

CHIAROSCURO

♥ ♥ ♥ ♥ ♡

This is a term used in painting to describe the contrasting effect of light and shadow. Focus on extremes of light and shade to take a dramatic and artistic photo.

Focus

- Recreate a famous chiaroscuro portrait or still life.
- Set up your shot and make sure to direct the light where you want it.
- Take a series of portraits and play with light and shade.

margoterrante/Instagram

bande.ra/Instagram

trevorbaum/Instagram

farmer_photography/Instagram

#chiaroscuro #lightanddark #shadows #studio365challenge

♥♥♥♡♡ PUDDLEGRAM

Make the most of a rainy day and take a reflective photo. You could focus on landscape, architecture or portrait!

Focus

- Take a series of rainy- day selfies, using puddles!
- Look for interesting light play in the reflection.
- Try flipping your photo upside down. Can you tell which is the reflection?

marcotamby/Instagram

arinyx/Instagram

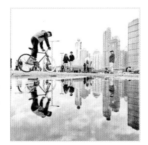
priboghani/Instagram

wcobbers/Instagram

#puddlegram #reflection #rainyday #studio365challenge

DOUBLE EXPOSURE

♥ ♥ ♥ ♥ ♥

A double exposure photo is a technique that combines one (or more) images into a single image. It might sound tricky, but it can even be done on a smartphone with a photo-editing app.

Focus

- Combine portraits with elements from nature.
- Add a sense of movement to your photos using this technique.
- Experiment with photos you already have and find your own style.

ducdubois/Instagram

marcusmailov/Instagram

repulsivelyplain/Instagram

brandonkidwellphoto/Instagram

#doubleexposure #layering #portraitlandscape #studio365challenge

 # PASTELS

Fill your photo feed with a harmonious series of pastel photos. From interior design and décor to flowers, food and fashion, your followers will love seeing a theme on your page.

Focus

- Create flat lays of your favourite items.
- Look for these colours whilst you're out and about and snap a picture.
- Aim to fill the entire view of your page in the theme, for a while, at least!

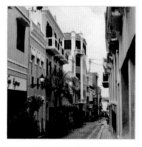

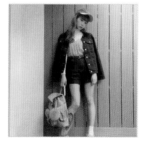

abreu.mnicole_/Instagram

vickiee_yo/Instagram

mim_11_11/Instagram

sophia_hime_/Instagram

#pastels #colourscheme #softcolours #studio365challenge

BOKEH

Bokeh, the Japanese word for blur, is a photography effect that creates strong blurs on out-of-focus light. If shooting with a smartphone, focus lock onto a close object, then turn your phone to your subject. This should cause a bokeh effect – experiment until you get it right!

Focus

- Try shooting at night. Make sure there are light sources to blur!
- Use the bokeh effect in your nature shots to draw the focus onto the subject.
- The festive period is the perfect opportunity for this style.

huylllooo/Instagram rafael_lucas/Instagram mmiklos/Instagram zulsahaja_photo/Instagram

#bokeh #lightblur #focus #studio365challenge

RULE OF THIRDS

♥♥♥♡♡

Add the grid option to your smartphone camera and you'll see a 3x3 grid — the rule of thirds is about placing the important parts of the image along the intersecting lines. The result is a more balanced, natural-seeming photo and is one of the first lessons budding photographers learn.

Focus

- Shoot some close-up portraits. Try placing the eyeline across one of the intersections.
- When shooting move your shot around and try to find the most pleasing composition.
- Break the rule of thirds — rules are there to be broken, after all!

yogaheryy/Instagram

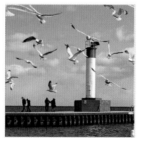
daystheylastforever/Instagram

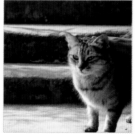
casmir.mathew/Instagram

photo.tips.advice/Instagram

#ruleofthirds #composition #balanced #studio365challenge

MINIMALISM

Characterised by sparseness and simplicity, minimalism in your composition can make a striking photograph. Look for few colours and modest patterns – don't be afraid of simplicity.

Focus

- Use depth of field to keep your images minimalist. Focus on the subject and blur the background.
- Bright or contrasting colours make for a great minimalist photo.
- Get up close – avoid distractions and snap a photo on the close-up.

skyywoo/Instagram

jim_p_/Instagram

tasssmania/Instagram

jordicirach/Instagram

#minimalism #lessismore #simplethings #studio365challenge

FACES IN THINGS

♥♥♥♡♡

Have you ever spotted a human or animal face in an inanimate object? Snap a photo and share with your followers to join in this hilarious hashtag.

Focus

- Add a funny caption to your photo. What would the object be saying?
- Search for faces in things every day for a whole week.
- Look for celebrity doppelgängers in inanimate objects.

juliemachair/Instagram

thegleamingunderbelly/Instagram

ron licata/Instagram

fiosh /Instagram

#facesinthings #iseefaces #facesinobjects #studio365challenge

HORIZONTAL LINES

Horizontal lines can convey a feeling of stability and calm in photography. Seek out shots with strong horizontal emphasis for a timeless, anchored shot.

Focus

- Horizons are the most common horizontal shot; use the horizon as a divider in your photo.
- Seek out horizontal patterns in architecture and try to capture the rhythms in your picture.
- Keep your eye out for natural shots that fit.

projectlineup/Instagram

codename.sky/Instagram

nefert.arg/Instagram

chinkui_bikes/Instagram

#horizontallines #horizon #timeless #studio365challenge

 # LIGHT PAINTING

You don't need a DSLR camera to capture an amazing light painting shot. Download an app to slow your phone camera's exposure and shutter speed, wait for a dark night, grab some torches and start painting!

Focus

- Spell out a word – anything you write needs to be backwards (or cheat and flip your photo!).
- Use different coloured lights to add details to your light painting.
- Ask a group of friends to help you create one huge masterpiece.

dadolove151/Instagram

fionlaiwy/Instagram

zaq.led/Instagram

samuelthefrenchy/Instagram

#lightpainting #longexposure #nightphotography #studio365challenge

I SAW THE SIGN

Everywhere we go we are bombarded with instruction and information in the form of signs. But aside from the ordinary, there are uniquely artistic endeavours all around you; from a local business, or a remnant from the past to random hand-drawn notes. What can you find?

Focus

- Signs are not limited to urban spaces; rural locations will have their share of unique ones too.
- Try to find examples of old and new.
- Look out for the quirky and funny notices you could easily miss.

doncolinphotographs/Instagram

signsafari/Instagram

signsoflifepdx/Instagram

the_archaic_folk/Instagram

#signspotting #signgeeks #ghostsigns #studio365challenge

MAGIC NUMBER

Three? It's the magic number. It might be three people, three pencils or three doughnuts. Whatever it is, all good things come in threes, so get snapping!

Focus

- You could have three items in the same shot...
- ... or you could place three shots in one frame to extrapolate or exaggerate!
- Try to tell a story or make your trio as unusual as possible.

hooptedoodles/Instagram

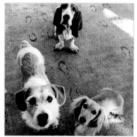

louiesaintlaurent/Instagram

shinaebb/Instagram

wonderstobehold/Instagram

#threeamigos #magicnumberthree #threestooges #studio365challenge

TAKE MY HAND

Your images are a representation of the world through your eyes and 'Take my Hand' shots are the perfect way to capture that. You could almost forget the camera was there. It's a great way to involve those who are experiencing adventures with you – even if they're camera shy!

Focus

- Try to link a variety of activities with a particular person.
- If you're with more than one pal, why not get everyone in shot holding hands.
- You can turn even the most regular outing into an interesting story with this technique.

heartbreak.cape/Instagram

hector_alvarez_m/Instagram

kristinism/Instagram

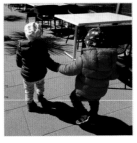

zoe_ben.liebe/Instagram

#takemyhand #followme #youandme #studio365challenge

 FOOD ART

Edible art is a real skill – you may discover a talent you never knew existed! Be as creative as possible and make the very best kind of art – one good enough to eat!

Focus

- On the plate, in the lunchbox, on the go.
- Make someone smile with the gift of an arty lunch.
- Don't limit yourself – kudos for restaurant-level food art!

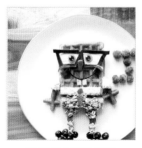
jacobs_food_diaries/Instagram

freedomcitysurf/Instagram

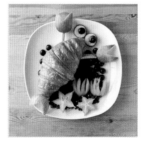
leesamantha/Instagram

foivigeller/Instagram

#foodart #foodartist #foodartgallery #studio365challenge

MIRROR MIRROR

You can create some incredibly awesome shots with mirror images. Perhaps you will choose a selfie shot or a friend striking a pose.

Focus

- You need to be clear of the focal point for this to work best.
- Play with depth of field to see what has the most impact.
- Try to frame the original shot so that both focal points are linked.

timey24/Instagram

tiedyesteve/Instagram

two_cutie_kitties/Instagram

mr_rsaunders/Instagram

#mirrorimage #mirrorgram #mirrorimages #studio365challenge

❤❤❤❤♡ THE WORLD OF WHITE

Tapping into the world of white can be quite a challenge to get right, but the effects are incredibly pleasing to the eye. Spend some time creating these trés chic shots and you won't be disappointed.

Focus

- The hardest thing to find is contrast, so choose your subjects wisely.
- Juxtapose things that would not normally fit to create drama.
- Concentrate on textures and shadows.

arnaudpitois/Instagram

julie_delvallee/Instagram

idlewoodelectric/Instagram

nina.e.zaronikola/Instagram

#white #whiteout #whiteonwhite #studio365challenge

BALLOONS

Whether party-ready or high in the sky, balloons = happiness. Spread some joy and fill your feed with hot air!

Focus

- A great way to inject some colour into your posts.
- Keep your eyes to the skies with some low-flying balloons, perhaps with passengers.
- Or you could set off some of the smaller variety against a bright blue sky!

prisma/Instagram

thegirltravels/Instagram

jhonatas israel.cl/Instagram

isopresso_balloon/Instagram

#balloon #balloonlove #balloonglow #studio365challenge

CRYSTAL BALL

This challenge requires a piece of extra equipment: a glass ball, and is better completed with a macro lens. Play with refractions instead of reflections by photographing a refracted image in a glass ball.

Focus

- Decide whether to place the glass ball image or the background upside-down.
- Try placing your glass ball into a puddle for refractions and reflections.
- Create a selfie using a glass ball.

_mr stormtrooper/Instagram

bmonborgia/Instagram

mie30423242/Instagram

stacey_griffin/Instagram

#crystalball #glassball #refraction #studio365challenge

VERTICAL LINE

Vertical lines in photography can convey a range of emotions from the strength and power of skyscrapers to the growth of trees and plants. Use vertical lines in your photography and see what mood you can capture.

Focus

- Vertically frame your photos for an extra impact.
- Try to keep the vertical lines perpendicular to the edges of the shot.
- Remember the rule of thirds – don't place a line dead centre unless the image is dramatic.

ambcetrencada/Instagram

rustydreadnouth/Instagram

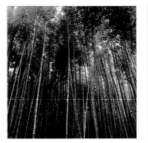
samlush/Instagram

adonamrin/Instagram

#verticallines #upanddown #strength #studio365challenge

♥♥♡♡♡ # NO FILTER PHOTO

#nofilter might be one of the most popular hashtags but it should be used sparingly. Use it to show the vibrant, real-life colours of a landscape or to show a portrait or photograph that is true-to-life.

Focus

- If you take a selfie and you're looking on-point, by all means show off with this hashtag.
- Use this challenge to capture the amazing colours of nature as they are.
- Use this challenge ironically to show just what's going on in real life.

boostedbluerocket/Instagram

paulajast/Instagram

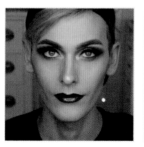
willdoughty/Instagram

dessy.arfiana/Instagram

#nofilter #reallife #noedit #studio365challenge

GIANT SQUARE

This type of photo takes up a whole 3x3 square in your Instagram® profile. Download an app to help you split a photo and make sure you start uploading from the bottom right and end top left.

Focus

- Alternatively create a 1x3 or 2x6 image.
- Use this challenge to show off an amazing view...
- ... or to show a close-up detail of something.

_adventureattendant /Instagram

doubled13718/Instagram

emmalozano/Instagram

zitronenfalter22/Instagram

#giantsquare #threebythree #bigphoto #studio365challenge

SAME THING 50 TIMES

This series of photographs will challenge you to look at your subjects in different ways. Shoot the same thing 50 times using the prompts below and share your favourite shots with your followers.

☐ 1 Whole subject
☐ 2 No filter
☐ 3 Close-up
☐ 4 Extreme close-up
☐ 5 From above
☐ 6 From below
☐ 7 From the left
☐ 8 From the right
☐ 9 Tilt angle
☐ 10 Long shot
☐ 11 Black and white
☐ 12 Sepia
☐ 13 Giant square
☐ 14 In full sunlight
☐ 15 In shadow

☐ 16 One light source
☐ 17 Macro
☐ 18 Out of focus
☐ 19 Sharp focus
☐ 20 Rule of thirds
☐ 21 Cropped off
☐ 22 Framed
☐ 23 Used as a framing device
☐ 24 Saturated
☐ 25 De-saturated
☐ 26 High contrast
☐ 27 One colour
☐ 28 Fish bowl
☐ 29 Pinhole

☐ 30 Panorama
☐ 31 Golden hour
☐ 32 Minute detail
☐ 33 Mid-section
☐ 34 Fill the frame
☐ 35 Light flare
☐ 36 Vintage filter
☐ 37 Soft edges
☐ 38 Forced perspective
☐ 39 Low angle
☐ 40 High angle
☐ 41 Underexposed
☐ 42 Overexposed
☐ 43 Contrasted
☐ 44 Flash

☐ 45 No flash
☐ 46 Motion blur
☐ 47 Find the lines
☐ 48 Upside-down
☐ 49 Selfie
☐ 50 In situ

samyhamusthafa/Instagram

#samething50times #differentangle #samebutdifferent #studio365challenge

FILL THE FRAME

This is a great challenge to undertake when you can't get out and about — but it works anywhere. Simply fill the entire frame with a close-up of your subject.

Focus

- Photograph objects in your home and see if your followers can guess what it is.
- Create a photo series of the same type of object, for example close-ups of fruit and vegetables.
- Look for interesting textures or colours.

casey_maryellen/Instagram

martah22/Instagram

jamay_photography/Instagram

twentyfivesmiles/Instagram

#filltheframe #supercloseup #whatisit #studio365challenge

PHOTO INCEPTION

♥ ♥ ♥ ♥ ♡

Photos of people taking photos... of people taking photos. You can push this as far as you want! Whether you're capturing a candid photo of a budding photographer or shooting a staged shot, these are really fun photos to take.

Focus

- Stand behind a friend who's taking a photograph and shoot their viewfinder.
- Street photography in a tourist location is a great place to shoot other shooters!
- If you have photographer friends, create a series of portraits of them with their cameras.

sumerlinsimpson/Instagram

ivebeenshot/Instagram

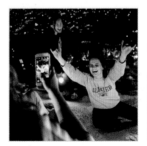
deseretnews/Instagram

frank3dot0/Instagram

#photoinception #shoottheshooter #photographer #studio365challenge

MONO

Shooting in mono, or using a black and white filter, can create dramatic and beautiful photographs. Look for subjects with a strong contrast between fore and background and interesting textures.

Focus

- Use a black and white filter to create moody landscape shots.
- Look for fine detailing such as foliage or clouds to add interest.
- Focus on finding a composition with good contrast of tones. You want light and shadow.

millionnastroeniy/Instagram

tking photo/Instagram

economou.ath/Instagram

ned bunnell/Instagram

#mono #blackandwhite #shadesofgrey #studio365challenge

♥ ♥ ♥ ♥ ♡ # TRANSMOGRIFY

This challenge is all about transformations. Transmogrify means to transform in a surprising or magical manner. Think of a piece of paper transforming into an origami masterpiece, or Clark Kent becoming Superman!

Focus

- Transform your photo through clever editing.
- Share a photo of a fancy-dress transformation.
- Look for transformations in progress – such as a butterfly emerging from a chrysalis.

melmar2000/Instagram

skirtarella2/Instagram

jenormond8/Instagram

jaguchi.t/Instagram

#transmogrify #transformation #beforeyourveryeyes #studio365challenge

EMPTY SPACE ♥♥♥♥♡

This challenge could be interpreted as finding a landscape that's empty (of what, that's for you to decide) or as looking at the negative spaces surrounding a subject in your photograph.

Focus

- Decide whether the feeling of emptiness is a positive or negative theme in your image.
- If you're exploring negative space make sure to focus on the background, not the subject.
- Clear skies or solid colours work best if you're focusing on the negative space.

throughjslens/Instagram

kotetoxadze/Instagram

art.thru.a.lens/Instagram

pmdwsn41/Instagram

#emptyspace #negativespace #minimalism #studio365challenge

 BACK IN BLACK

Backing your subject in black or shadow can make the focus of your photograph really pop. Use clever lighting to really make the most of your subject.

Focus

- Look for strong contrasts of shadow and light for a natural shot...
- ... or set up your subject on a black background and shoot away.
- Wait until dark and use a torch to illuminate your composition.

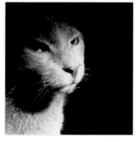

borghallen/Instagram

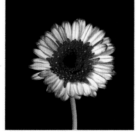

becky.turner30/Instagram

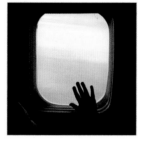

sayhellojo/Instagram

cljff/Instagram

#backinblack #shadows #highcontrast #studio365challenge

OPTICAL ILLUSION

You can make things look very different from reality in your photographs with clever camera angles and strategic placement. Trick your follower's eyes and create an optical illusion!

Focus

- Get down on the ground and angle your shot vertically so it looks like your subject is climbing.
- Use the depth of field to play a trick on your followers.
- Look for incidental moments of illusion and capture these, such as a well placed cloud!

gerberagirl308/Instagram

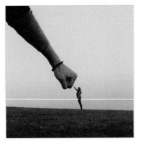

timoment/Instagram

kajumski/Instagram

watermarqdesign/Instagram

#opticalillusion #eyetrick #looktwice #studio365challenge

 # LAMP LOVER

Lamplight is hard to beat. It's somewhere on the light scale between candle and big light. Lamp-loving is a real thing, because lamps are beautiful. Don't believe us? See for yourself.

Focus

- Focus on finding lots of different styles and placements.
- Be sure to shoot the lamp in its environment in daylight...
- ... and lit up in darkness as a functional piece of furniture.

elgangst/Instagram

formicagroupeu/Instagram

vertollleta/Instagram

i_am_anyone_/Instagram

#lamp #lamploversoftheworldunite #lampshade #studio365challenge

BLACK AND GOLD

It's a somewhat pleasing combination: the matte and the shine. It's not so much two extremes of colour but of textures. Be bold, enjoy black and gold!

Focus

- Shoes, nails, clothes, there's so much scope with this theme.
- Perhaps you're hosting a black and gold party...
- ... or you and your friends are dedicating an entire day to it!

newtwiststore/Instagram

umbrellacarnage/Instagram

maayanush246/Instagram

beaubertie/Instagram

#blackandgold #blingbling #blackandgoldnails #studio365challenge

 # WE'RE LIKE CRYSTAL

Some people believe in the healing properties of crystal, while others just like the way they look. Either way you're almost guaranteed to get some beautiful images.

Focus

- You can really let colour take centre stage here.
- Why not get a close up of the patterns within a particularly pretty specimen...
- ... or line up a selection of different shapes and sizes.

mystic.key.meditations/Instagram

happy.holistic.hippie/Instagram

kimilatta/Instagram

ocelomeh.artisans/Instagram

#crystal #gems #quartz #studio365challenge

WRIST CHECK

Something we always seem to be running short on is time. Take some time out and show off your style with a snap of your wristwatch.

Focus

- Show off your location subtly with a snap of your watch in front of an interesting background.
- Fill the frame with the watch face to really focus on the style.
- Home time? Take a snap to celebrate the end of the working day.

whos.watching/Instagram

cyclo furious/Instagram

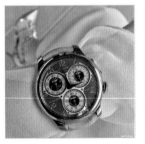

aytystyle/Instagram

watchesnlifestyle/Instagram

#wristcheck #wristwatch #timetogo #studio365challenge

36 EXPOSURES

Hark back to the days of film and limit yourself to 36 exposures only on a day out. Shoot as if you're using a roll of film: no re-taking and no more than 36 shots!

Focus

- Digital photography has meant the loss of those perfectly imperfect snaps...
- ... glare, chopped off heads and red eyes are all part of the fun.
- Better yet, find an analogue camera and challenge yourself!

utahfamilyadventures/Instagram

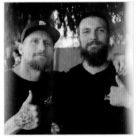
somethingfilmrelated/Instagram

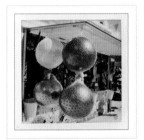
lommi19/Instagram

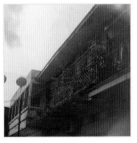
xberskyx/Instagram

#36exposures #analoguephotography #onechancephotography #studio365challenge

SHADOW ONLY

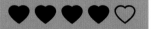

Shadows can be a powerful part of photography, so why not capture the shadow only?

Focus

- See if your followers can guess the subject from the shadow.
- Merge shadows together to make a humorous or interesting subject.
- Use a strong light behind your subject to make the shadow sharp.

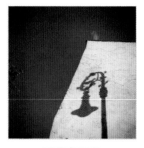

paxtelex/Instagram dnkyp/Instagram http.hotteok/Instagram detaileddisney/Instagram

#shadowonly #shadow #shady #studio365challenge

STILL LIFE

The still life has been the staple of artists for hundreds of years, so why not create a photographic still life?

Focus

- Think beyond the fruit bowl and modernise your still life.
- Arrange objects that are meaningful to you to tell your followers a bit about yourself.
- Make your photograph look like a painting with clever editing and lighting.

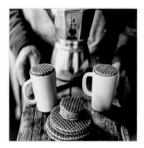

naughtyteas/Instagram kak_obrazec/Instagram anastasia_lanis/Instagram radovanmagdalenic/Instagram

#stilllife #modernstilllife #composition #studio365challenge

ART, NATURALLY

Using natural objects such as petals and leaves is a great way to create a mixed media piece of artwork. Combine with pencil drawings, paper cuts or anything at all and then photograph your creation.

Focus

- Rose petals make a great addition to a fashion sketch.
- Get in close with your camera to pick up the textures of your materials.
- Try creating something entirely out of natural materials.

aesellerose/Instagram

petals_to_print/Instagram

bookhou/Instagram

leafart/Instagram

#artnaturally #mixedmedia #pencilandpetals #studio365challenge

EXTREME EDIT

Search through your photo library and find a picture you didn't deem Insta-worthy and edit it to the extreme. Be artistic and brave and share your extreme edit with your followers.

Focus

- Boost up the colour contrast...
- ... or make it super saturated.
- Don't be afraid to apply multiple edits to one photo.

israfeel.khaan/Instagram

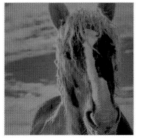

pappybradford/Instagram

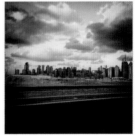

picsonthemove/Instagram

artistik_xpressions/Instagram

#extremeedit #colourcontrast #doublefilter #studio365challenge

MAGNIFY

Oh the fun you can have with a magnifying glass! Perfect for portraits and close-ups.

Focus

- Take a series of funny portraits and ask your subjects to magnify different features.
- Show intricate detail or tiny objects in close-up through a magnifying glass.
- Keep the magnifying glass in shot to frame the photograph.

capturethroughthelens/Instagram

ihanayogi/Instagram

keng0924/Instagram

aural770/Instagram

#magnify #magnifyingglass #closeup #studio365challenge

REPETITION

♥ ♥ ♥ ♥ ♡

Repetition in life can be boring. Repetition in photographs can be extremely satisfying. Look for shots featuring strong repeating patterns.

Focus

- Look to nature for repetition, you'll be amazed at what you'll find.
- Alternatively, man-made constructions offer a very rigid, repetitive structure to your photographs.
- Try editing your photo to add in your own repetitions.

jase_photo/Instagram

creativewton/Instagram

chebu214chebu/Instagram

vivinwonder/Instagram

#repetition #pattern #multiexposure #studio365challenge

DIPTYCH-ORAMA

Diptychs are two images that are either from the same photo session or are opposing or contrasting one another. Create a stunning diptych to share with your followers.

Focus

- You could bring together two ideas you feel complement one another.
- Perhaps the same shot but at different times of day or years apart?
- Or highlight your two favourite images from your latest photo session.

john_maclean_photo/Instagram

ettashonarts/Instagram

call_me_gwen/Instagram

kapitolphoto/Instagram

#diptych #mixedmedia #twoforone #studio365challenge

THING WITH FLOORS

The creative hashtag #ihavethisthingwithfloors is perfect for those of us obsessed with looking down at the gorgeous floor tiles and carpets gracing the most unexpected of buildings.

Focus

- If you're visiting a historic building or lavish place, document the style by photographing the floor.
- Show your feet for additional interest.
- From the gaudy to the glorious, anything that isn't laminate is worth a photo!

one80s/Instagram

johnnyfoxrocks/Instagram

alexandre_sadin/Instagram

source_d_interieurs/Instagram

#ihavethisthingwithfloors #tiles #carpet #studio365challenge

NOTHING IS ORDINARY

♥ ♥ ♥ ♥ ♡

If you want to improve your photography you need to develop a keen eye for detail and composition. Look for the extraordinary in the blindingly ordinary for this challenge.

Focus

- Look out for small details or something slightly off about a subject or landscape...
- ... or celebrate the beauty of the ordinary by elevating a subject through photography.
- Use lighting and composition to make the ordinary extraordinary.

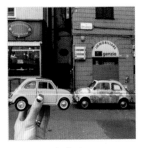

pazitea/Instagram

boraesiz/Instagram

kiritte/Instagram

laetitiafinetphotography/Instagram

#nothingisordinary #extraordinary #lookagain #studio365challenge

EMPTY CHAIRS

This creative hashtag is based around a very simple concept: empty chairs. Whether broken and abandoned, or still warm, an empty chair can evoke a range of emotions and ideas.

Focus

- Look out for chairs in unusual places and try to look for a story in your photograph.
- An empty chair doesn't mean an empty space; convey the atmosphere of your setting.
- Chairs can be very personal; why not take a portrait of a person using their favourite seat?

asamuel/Instagram

mattlouder/Instagram

lecaldecasa/Instagram

gonultuter/Instagram

#emptychairsproject #favouritechair #isthisseatfree #studio365challenge

16X9

Move away from the square format and post a landscape shot. You'll need an app to help you resize your photo but you'll find breaking away from the 1:1 square will allow your photos space to breathe.

Focus

- Think about which photos you want to post in 16x9.
- This format lends itself particularly well to the rule of thirds.
- Fill the frame, or place your subject off centre for an interesting composition.

icantouchthesky/Instagram

emmiekuenen/Instagram

#16x9 #landscapeshot #ruleofthirds #studio365challenge

 # HARNESS THE SQUARE

Make real use of Instagram's 1:1 square default and compose your photographs with this format in mind. Think about where you're placing your subject and then crop to perfection.

Focus

- Put your subject in the centre or use the rule of thirds to your advantage.
- Make use of symmetry and lead your viewer's eye to the centre of the square.
- Use empty space or fill the entire square.

not_another_nickname/Instagram

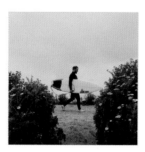

mattbucknall/Instagram

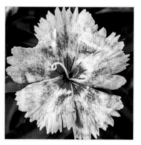

shandilya.photo/Instagram

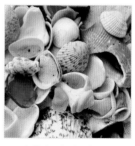

seeinglifethroughmylens/Instagram

#harnessthesquare #squarephoto #centre #studio365challenge

YOU'VE BEEN FRAMED

♥ ♥ ♥ ♡ ♡

Add a border or frame to your photo either during shooting or in editing to draw your viewer's eye into the photograph. Extra points if your subject interacts with the frame.

Focus

- Look for natural borders. You could use the leaves on a tree to frame a landscape shot...
- ... or use a window or opening to shoot through, capturing the opening as a border.
- Use editing software to add a border afterwards, but make sure it suits the photo.

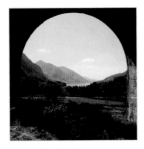
hannplant/Instagram

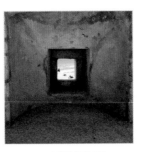
manusnake91/Instagram

loulousg/Instagram

nicolasrachlinephotography/Instagram

#framed #border #drawintheeye #studio365challenge

FUTURISTIC

♥♥♥♥♡

The future is coming and there's no stopping it. Look out for signs of the future and share something truly futuristic with your followers.

Focus

- Look to architecture, fashion and technology for glimpses of the future.
- Compose your photo and edit it to reflect the futuristic vibes.
- Think about your own future: what do you think it holds?

fusnafus/Instagram

rizkanataart/Instagram

thevrcinema/Instagram

caityannedalton/Instagram

#futuristic #tomorrowsworld #thefuture #studio365challenge

FIND THE LIGHT

Choose an interesting object that you can easily move between locations to act as your subject in this lighting challenge, and then shoot it in each of these lighting conditions.

- ☐ Side lit
- ☐ Back lit
- ☐ Rim lit

- ☐ Ambient
- ☐ Soft
- ☐ Diffuse

- ☐ Hard
- ☐ Spotlight
- ☐ Artificial

- ☐ Candlelight
- ☐ Cool
- ☐ Warm

whyvonnegiraffe/Instagram

imwithmargot/Instagram

s_p_g/Instagram

varun_evolvist/Instagram

#findthelight #lightingexperiment #sidelit #studio365challenge

♥♥♥♥♡ HALF

This challenge isn't about making half the effort; it's about shooting half of something. Two halves make a whole — allow your followers to fill in the other half using their imagination.

Focus

- Crop the photo so only half the subject is in view or obscure half the subject with something in the foreground.
- Cut a piece of fruit or veg in half to show the inside.
- Fill your frame with half and half.

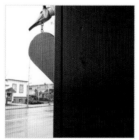

patinamoon/Instagram denstorm/Instagram thisoneroars/Instagram borghallen/Instagram

#half #twohalves #halfandhalf #studio365challenge

PERFECT PAIR

♥ ♥ ♥ ♥ ♡

Salt and pepper, your favourite shoes, identical twins. Things are better in pairs! Look for a harmony in your composition between the two subjects.

Focus

- Look out for pairs next time you're out and about. You'll soon notice pairs everywhere!
- Do you know a perfect pair of people? Create a personalised portrait photo shoot for the pair.
- Alternatively photograph one half of the pair. Make it obvious something is missing.

fiddlejill/Instagram

sparta411/Instagram

bigpeabella/Instagram

kd_schmidt/Instagram

#perfectpair #twoforone #seeingdouble #studio365challenge

♥ ♥ ♥ ♥ ♡ INCOMPLETE

Photograph things not finished and leave your fans wanting more. From unfinished buildings and works-of-art in progress to things broken and in disrepair, interpret this challenge in your own, complete, way.

Focus

- Turn your camera to architecture. Look for the very new, the not even finished, and the very old.
- Remove something from a complete setup and photograph it.
- You could take a complete photo and cleverly frame the image so that it's missing something important.

saun24/Instagram

swell_shell/Instagram

b.bennettphotography/Instagram

cilinos_girl_22/Instagram

#incomplete #somethingmissing #inprogress #studio365challenge

CROWDED

Two's company but three's a crowd and more than that, well... pack a shot with a crowd of whatever you want, from people and animals to bric-a-brac and untidy spaces.

Focus

- This is a great way to photograph repeating subjects.
- If you want to photograph a crowd of people get up high to capture as much as possible...
- ... or get inside the crowd to capture a sense of immediacy.

fiddlejill/Instagram

britt_ttt/Instagram

gianlucavitelliphoto/Instagram

365_today/Instagram

#crowded #cluttered #threesacrowd #studio365challenge

❤️ ❤️ ♡ ♡ ♡ # COLOUR POP

Look for those bright pops of colour on dark backgrounds and capture them. Enhance the brightness through editing to really make the colour stand out.

Focus

- Look out for moments of unexpected colour when you're out and about.
- Set up a portrait shot in a dark room and use a coloured light to add that pop.
- Alternatively, reverse out the colour pop with a dark subject on a bright background.

elegance_revisited/Instagram

iryvni/Instagram

luvsinha/Instagram

tezamar11/Instagram

#colourpop #brightinthedark #bright #studio365challenge

DIAGONAL LINES

Look for diagonal lines in nature, architecture or objects, or create a diagonal by framing your photo in a particular way.

Focus

- Create an impression of movement by using strong diagonals right across the frame...
- ... or create a sense of depth with lines that widen.
- Experiment with using lots of lines, or just one, strong diagonal.

thinglove/Instagram deandraelayne/Instagram lanweca/Instagram sweathesmallstuff/Instagram

#diagonallines #diagonally #cornertocorner #studio365challenge

♥♥♥♡♡ # DEAD CENTRE

Throw out the rule book, ignore the common compositions photographers use and place your subject or focus dead centre of your shot.

Focus

- This is a great way to take a portrait, place your subject centrally with an uncluttered background.
- Experiment with using the default square photo and a landscape shot.
- If you're taking a skyline shot, place the tallest building dead centre for a dramatic image.

inst_by_lviv/Instagram

chanpanjan/Instagram

karlott_a/Instagram

weiwei8012/Instagram

#deadcentre #central #drawtheeye #studio365challenge

LAMP POST

From the ornate, old-fashioned lamp posts to streamlined modern day posts, we walk past and ignore lamp posts on a daily basis. Time to turn your lens to these literal beacons of light.

Focus

- Historical cities and charming villages often have interesting, ornate lamp posts.
- Line them up, and take a shot down a street, focusing on the lamp posts.
- Use the soft glow from a lamp post for a night time portrait.

girlandbackpack/Instagram

_mariee13/Instagram

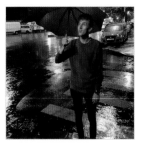

idrian09/Instagram

traveling_sebi/Instagram

#lampposts #leaningonalamppost #light #studio365challenge

♥ ♥ ♡ ♡ ♡ CHERRY ON TOP

Fruit and vegetables bring wonderful colour to our kitchens and meals. Capture the amazing shapes, colours and textures of your favourite five-a-days.

Focus

- If you grow your own, document the process from seed to plate.
- Pop a cherry on top of your cakes and take a photo. It's healthy if it's got fruit on it!
- Look for unusual shapes and colours and join the #uglyfruitandveg movement.

the allotment chap/Instagram

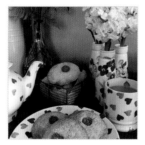
emmas colourful home/Instagram

sonainfashion/Instagram

nikijabbour/Instagram

#cherryontop #fiveaday #uglyfruitandveg #studio365challenge

RADIAL PATTERN

Look for lines that radiate from a central point for an interesting and dynamic shot. You're likely to find these patterns in nature, but look at man-made structures, too.

Focus

- Everyone takes flower photos. Focusing on a radial pattern can give a new perspective.
- The spokes of a wheel are a great example of a man-made radial pattern
- Experiment with filling the frame and just showing a part of the pattern.

jainmansa/Instagram

pam_crossley_ceramics/Instagram

ordinaryirregular/Instagram

min.ke/Instagram

#radialpattern #naturepattern #manmadepattern #studio365challenge

♥ ♥ ♥ ♥ ♡ SYMMETRY

Symmetry is all around us; whether it's in nature, architecture or a moment of pure chance. Composing your photos to add an element of symmetry can create a harmonic, aesthetically pleasing and balanced photo.

Focus

- Look for a vertical line of symmetry – the line will be perpendicular to the horizon...
- ... alternatively seek out horizontal lines of symmetry, where the line is parallel to the horizon.
- It's often said that symmetrical faces are the most beautiful. Look out for symmetry in your portraits, or edit to create a symmetrical face.

lalolin14/Instagram

dombuerkle/Instagram

derykyang/Instagram

nurlankgz/Instagram

#symmetry #symmetrical #mirrorimage #studio365challenge

NEONS

♥♥♥♥♡

Shoot brighter-than-bright neon colours and then up the effect by altering your saturation, contrast and brightness.

Focus

- Look out for neon signs – shoot these in darkness for a bright effect.
- Take a portrait under neon lights to give your subject a bright glow.
- Highlight neon colours by contrasting them with a plain background.

saiyan_prince7/Instagram

thecreepypie/Instagram

rywhatsgood/Instagram

j.schostokart/Instagram

#neon #neonlights #brighterthanbright #studio365challenge

♥ ♥ ♥ ♥ ♡ # RAINBOW LIGHT

To capture rainbow light you'll need a very lucky set of circumstances, or you can create your own rainbows using things you have around the home.

Focus

- Create a rainbow using a mirror, a pan of water, a CD or a prism.
- Rainbow light portraits are a popular trend. Position your subject into the light and snap away.
- Show your followers how to make their own rainbow.

bitter_violet_dreams/Instagram

marieeeellle/Instagram

joven_bahxd/Instagram

prismaticperceptions/Instagram

#rainbowlight #prism #refractedlight #studio365challenge

HEART SHAPED

The heart shape is an evocative symbol of love. It can represent romance, friendship and family. Look out for hearts and share your favourite heart-shaped image.

Focus

- Look for hearts in nature, from clouds and pebbles to petals and leaves.
- Frame a portrait using a heart shape.
- Spread the love and undertake this challenge in the run up to Valentine's Day.

casteleinj/Instagram markos_saa/Instagram baristaaaronshin/Instagram lesfrotteurs/Instagram

#heartshaped #iheartyou #iheartit #studio365challenge

ONE COLOUR

♥ ♥ ♥ ♥ ♡

Layer a photo using one predominant colour. You could set up a shot or keep your eye out for natural, coincidental layering.

Focus

- Take a portrait of someone dressed in one colour, on a similarly coloured background.
- Focus on the range of textures and details in the different elements in your photo.
- Create a pleasing flat lay of pretty objects in one colour way.

pinkmilkteahime/Instagram

uldigart/Instagram

abahouse minami horie/Instagram

pictureparkstudios/Instagram

#onecolour #samecolour #colourlayer #studio365challenge

TUNNEL VISION

Look for the light at the end of the tunnel for this artistic challenge. Next time you're in a dark tunnel-like space, look for the light and shoot it.

Focus

- Position your shot to focus on a subject at the end of the tunnel.
- Look for natural as well as man-made tunnels.
- Play with the contrast between light and dark. Use light flares to your advantage.

wandajones13/Instagram

ilinabilahh/Instagram

deshatanner/Instagram

bradoliphant/Instagram

#tunnelvision #lightattheendofthetunnel #dark #studio365challenge

♥♥♡♡♡ # LEADING LINES

Use leading lines in your composition to guide your viewer's eye from the bottom of the picture to the top. Most leading line photos involve roads, but aim to be more creative and look for alternatives.

Focus

- Get low or close to the start point of your leading line, so it's wide at the bottom of your photo and tapers to the top/horizon.
- Look for leading lines on small objects, from man-made to natural.
- Use a simple leading line such as a path to draw the eye to a dramatic landscape at the end.

lecameron/Instagram

rikki /Instagram

wdp photographyinstructor/Instagram

fhotosthatspeak/Instagram

#leadinglines #followthelines #upahead #studio365challenge

PHOTO MAGIC

Use perspectives to your advantage and create some photo magic for funny, look again photos.

Focus

- Play with the depth of field to trick your viewer's eye.
- Take a funny portrait and make it look as if something's growing out of their head.
- Timing and positioning is essential for photo magic, so make sure you've planned your photo and checked everything before you snap.

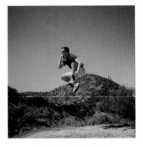

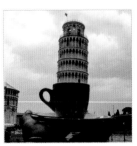

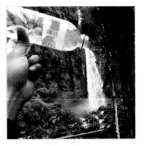

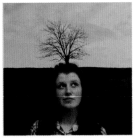

dj_smithers/Instagram

tomtribus/Instagram

mr.ningrat/Instagram

pyramids_of_darkness_and_light/Instagram

#photomagic #phototrick #lookagain #studio365challenge

♥♥♥♡♡ # THE CORNER

Interpret this one however you wish. On the corner, around the corner, cutting corners, corners of the world. Be artistic and be brave.

Focus

- Walk around your local area and look for buildings on the corner.
- Everyone loves angles in photography. Look for some right-angled corners.
- You never know what's around the corner. Give your fans a sneaky peek around a corner.

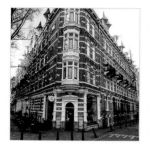
marilenadm/Instagram

art.thru.a.lens/Instagram

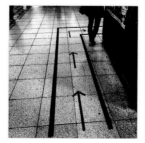
kouheisasa724/Instagram

ksenia.rey611/Instagram

#thecorner #aroundthecorner #onthecorner #studio365challenge

SPLASH!

This challenge is all about timing. Whether it's splashing in puddles or a huge splash made from jumping into a pool, capture the moment in all its glory.

Focus

- Use the burst mode to capture a quick succession of shots, then choose the best.
- Step back or make sure you've got waterproof equipment!
- Have a biggest splash competition with your friends. Use your photos to judge the winner.

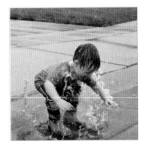

skydiverpac/Instagram

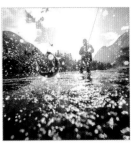

north40flyshop/Instagram

tonyroma4646/Instagram

ilyarem/Instagram

#splash #puddles #cannonball #studio365challenge

♥♥♥♥♡ CINEMATIC

Make your photos look as if they're straight out of a film with a stunning shot and strong, popping colours.

Focus

- Edit the colours in your landscape to make it look like a movie set.
- Recreate your favourite movies and set up a scene, with characters in place.
- Look for life copying art and take photos reminiscent of famous movie scenes.

aliashollygolightly/Instagram

twario14/Instagram

furtherintowonderland/Instagram

d_girl77/Instagram

#cinematic #movies #iconicscene #studio365challenge

MUSICAL INSTRUMENT ♥♥♥♡♡

The craftsmanship that goes into creating musical instruments is certainly worth celebrating. Share some gorgeous snaps of your favourite instruments.

Focus

- If you're a musician or know someone that plays, take some portraits whilst practising.
- Head to a music shop or a museum that has an instrument collection to capture a range of instruments.
- Focus in on the details, from pearl inlays and shiny machine heads to pedals, valves and mouthpieces.

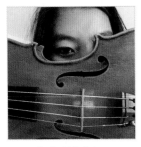

ashleytheviolinist/Instagram

meghart10/Instagram

treasuredrums/Instagram

jennifer_mullins_photography/Instagram

#musicalinstrument #musician #musiclesson #studio365challenge

♥ ♥ ♥ ♥ ♡

LOUD

Capture a moment that just screams noise, loudness and volume, whether it's an animal mid-call, a jumping party or a loud and colourful outfit.

Focus

- Next time you're shooting out and about, listen as well as look and see if you can capture the source of the sound.
- Try to capture images of familiar sounds, so that the image evokes the sound for the viewer.
- You could also create an image in anticipation of sound and photograph something capable of making lots of noise!

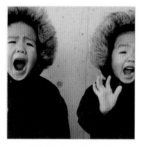

futago_no_utarita/Instagram

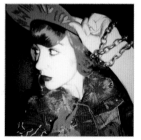

gangstagranofficial/Instagram

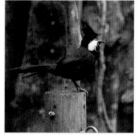

steve_russell5/Instagram

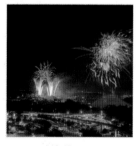

cwlanford/Instagram

#loud #shouting #noisy #studio365challenge

TWO TONE

Focus on just two colours in this picture. Create a dramatic image by selecting two contrasting colours, or look out for natural and candid occurrences.

Focus

- Get in close and fill the frame to avoid any extra colours creeping in.
- Frame a bright colour or a contrasting coloured background for maximum effect.
- If in doubt go for the fail-safe partnership of black and white.

britt_ttt/Instagram

tagarfe/Instagram

flat5thvintage/Instagram

naoyukimiura8732/Instagram

#twotone #twocolours #blackandwhite #studio365challenge

♥♥♥♥♥

PHOTO PUN

Tickle your followers' funny bones and create a photographic pun. Use props and an uncluttered background to make your joke.

Focus

- This challenge will take some preparation. Get your concept and your props ready.
- Take a familiar saying and twist it with your picture pun.
- Explain your pun in the description just in case people don't get it immediately.

lulabelle3008/Instagram

k80denight/Instagram

picturingjuj/Instagram

hushpup3333/Instagram

#photopun #punny #everydaycomedian #studio365challenge

BLUE HOUR

Blue hour, as opposed to golden hour is the hour before sunrise and the hour after sunset when the sky is dominated by purple and blue hues. Get out there and shoot those gorgeous colours.

Focus

- Combine this challenge with your golden hour shots and stay in the same location for both.
- Head somewhere iconic, it'll look amazing in the purple-blue light.
- This is a great opportunity to capture some inky silhouettes in the background.

gtphotography_gareth/Instagram krissawindaru/Instagram yogeshgupta1976/Instagram supershinshin/Instagram

#bluehour #sunset #sunrise #studio365challenge

 # LEVITATION

There are several techniques to this and a multitude of outcomes, most involve some clever editing. Done well they are always very cool. Enjoy putting the 'wow' into your photography.

Focus

- Mix it up between human and object – or both!
- Make sure your edits have taken shadow and light into account.
- Keep colours contrasting to ensure ultimate effect.

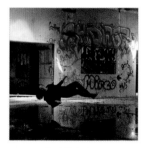

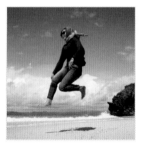

melinalights/Instagram epicyaz/Instagram dinapriana/Instagram antoniacnst11/Instagram

#levitation #floating #illusion #studio365challenge

BLUR

Now, we're not talking Britpop here, nor are we talking about a bad photo. No, this is intentional blurring to create effects of distance and motion or just plain artiness!

Focus

- You might be capturing a moving object.
- You may be depicting a shallow depth-of-field.
- You may be softening a portrait. Experiment and have fun with this.

uncreative.photos/Instagram

kipdavismyers/Instagram

fxckthebadvibes/Instagram

xdarkglobe/Instagram

#blurred #photoart #depthoffield #studio365challenge

 TEXTURE

Sumptuous combinations of texture are everywhere and are the fruit of aesthetic pleasure. They deserve the limelight. Make them the headline on your photo feed.

Focus

- Good texture pictures look almost 3D.
- If you want to reach out and touch it then you're on the right track.
- Wait for a wave of congratulatory comments, it's a weirdly emotive subject piece!

cowtanwashingtondc/Instagram

smeekwoodworks/Instagram

tanjajovic/Instagram

vtrutschel/Instagram

#texture #textureholic #texturelover #studio365challenge

MEASUREMENTS

We live in a society that measures everything: weight, height, amount, time, distance. Look out for these measurements and capture them in an unusual, interesting way.

Focus

- Spend a day looking through your camera for anything that measures – you'll be surprised at how many you'll find.
- Contrast modern measures with their predecessors. Digital vs. analogue.
- Get up close to show the details of the numbers.

victoriapeat/Instagram vishalsingh_starky/Instagram catswhisker/Instagram abrilowska/Instagram

#measurements #measuring #howmuch #studio365challenge

♥ ♥ ♥ ♡ ♡ RUST

Although rusting metal represents decay and corrosion, it has a certain attractive, aesthetic appeal to it. The older the item, the more russet the rust, the better it looks.

Focus

- Find the beauty in the rusting objects by focusing on colour and shape.
- Look for contrasts between the surrounding area and the corroding metal.
- Large structures such as vehicles and corrugated roofs can make striking photos.

clicks_by_saad/Instagram

phothoggraphy/Instagram

matt94hew/Instagram

zorino/Instagram

#rust #rusting #corrosion #studio365challenge

DISTORTION

♥♥♥♥♡

There are plenty of ways to distort a photo, both whilst taking it and during the editing process. Experiment with both and share your best distortions with your followers.

Focus

- Look for natural distortions in glass and water.
- Force a distortion by using a lens or app, such as the fish eye.
- Push your editing to the extreme to distort your original image.

xxgenticxx/Instagram

wcmaguiar/Instagram

bearbass /Instagram

topbrahman/Instagram

#distortion #distortedimage #abstract #studio365challenge

♥ ♥ ♥ ♡ ♡ AFLOAT

Take to the water and share your interpretation of being afloat. Whether that's taking a boat trip around a new city or capturing the lives of those who live beside waterways.

Focus

- Head to the docks during sunrise or sunset for some gorgeous silhouettes.
- Boats are full of small, intricate details; get your camera ready for some close-ups.
- Sailors, fishermen, rowers: create a portrait of those that live and love boats.

straight.way58/Instagram louisevanhout/Instagram simone wit/Instagram najiaxin128/Instagram

#afloat #boatlife #sittingonthedock #studio365challenge

EERIE

Capture the creepy with this photo challenge. Look out for mysterious happenstance or otherworldly vibes – or add these in using editing or shooting techniques.

Focus

- Foggy mornings or nights create extremely creepy photos – especially if your location already has the spook factor.
- Create a "ghost" by using a long exposure. Ask a model to stand in front of the camera and then move out of shot.
- Look out for things that just seem a little bit mysterious, or that make you shiver.

andreaanderson12/Instagram

gert_van_pottelberge/Instagram

smarttomato2/Instagram

sunnylux/Instagram

#eerie #spookfactor #ghost #studio365challenge

❤❤♡♡♡

BIG AND SMALL

Little and large, tall and short, big and small. These contrasts make great photos, whether you're photographing people, animals, places or objects.

Focus

- This is a great way to show the scale of a place or building. Simply place a person in the shot for perspective.
- Look for humorous size differences. If you're very tall, ask a short friend for a friendship snap.
- Focus on children and adults, and show the bond between small and big humans.

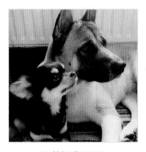
mrs_bishop/Instagram

stargazerjuji/Instagram

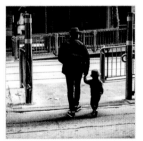
frmitchum/Instagram

nauticalsteel/Instagram

#bigandsmall #littleandlarge #contrast #studio365challenge

FAIRY TALE MOMENTS

Have you ever been out and about and suddenly been transported into a fairy tale by a charming countryside cottage or a tree that looks as if it's been enchanted? Share your fairy tale moments with your followers.

Focus

- Keep your camera handy at all times. You never know what fairy tale vista is hiding around the next corner.
- Head out in the early morning or late evening to capture those fairy tale landscapes in the mist.
- Do you have a favourite fairy tale? Share a photo that represents your favourite story.

sg_aguila/Instagram

brooke_klay/Instagram

alexa_verg/Instagram

fruzsinyuszi/Instagram

#fairytale #fairytaleforest #enchanted #studio365challenge

❤ ❤ ❤ ❤ ❤ SLOW SYNC FLASH

Use a slow shutter speed with a flash during the exposure for a fun, striking image. Best taken on proper kit, but of course, there's an app that can recreate this.

Focus

- Combine this challenge with a bit of light painting for a bright, dynamic photo.
- That long exposure is great for capturing movement in photos.
- Use that flash to illuminate the scene.

katieraephotography/Instagram

krisanatreviphoto/Instagram

sarceq/Instagram

purdy.photography/Instagram

#slowsyncflash #longexposure #portrait #studio365challenge

BUBBLES

The easiest way to make someone smile and relive their childhood: bubbles. Even better when it's captured on camera.

Focus

- Capture someone's reaction to blowing bubbles, whether they're a child, adult or animal.
- Perhaps you enjoy a bubble bath? Capture all that froth and foam.
- If you prefer your bubbles poured into a glass, raise a glass to your followers.

stepannegur life/Instagram

brucesdoggydaycare/Instagram

chasingthesun.ts/Instagram

agatha izabella/Instagram

#bubbles #bubblebath #somanybubbles #studio365challenge

♥ ♥ ♥ ♥ ♡

FIREWORKS

The ultimate in extravagant celebrations – fireworks are a photographer's dream: vibrant colours, flashes of light, amazing shapes. Just make sure you're ready to capture the display.

Focus

- Think about where the best place to photograph the display will be from...
- ... getting away from the crowds and in a high position is ideal.
- The best tip for photographing fireworks is to TURN OFF YOUR FLASH!

mikanala/Instagram

asim_sn/Instagram

uk_rainbow_7/Instagram

_fly_trilly_/Instagram

#fireworks #display #celebration #studio365challenge

GEOMETRIC SHAPES

♥♥♥♡♡

Use your camera to seek out geometric patterns in everyday life. Look in nature, street art and architecture. Turn your camera to the unexpected!

Focus

- Join the #geometryclub to look at buildings in a different way.
- Find patterns in nature only.
- Seek out an architectural aesthetic such as art deco.

geometryclub/Instagram

giulioska00/Instagram

kareen_salb/Instagram

desthex_artworks/Instagram

#geometry #patterns #geometricnature #studio365challenge

♥♥♡♡♡ WATER, WATER EVERYWHERE

From reflective puddles in the middle of a city to under-the-ocean shots, water offers plenty of Instagrammable moments. Find an interesting angle and challenge yourself to take some stunning water-focused photographs.

Focus

- Go out in the rain and focus on the water drops.
- Find a different angle and show a landscape as a reflection.
- Capture the movement of water.

travelelation/Instagram

jerm_cohen/Instagram

yngwie_traveladdict/Instagram

vladviper/Instagram

#waterchallenge #rain #h2o #studio365challenge

IN MY BACK YARD

♥ ♥ ♡ ♡ ♡

Spend a week seeking out interesting photos and stories on your doorstep. Stay local and share the amazing things that can be found in your back yard with your followers.

Focus

- Choose to focus on natural or urban subjects for the entire week.
- Photograph small details that others may not notice.
- Share your favourite things about your local neighbourhood.

pruetully/Instagram

mtigent/Instagram

thegeogarden/Instagram

iamnatasha/Instagram

#inmybackyard #neighbourhood #local #studio365challenge

MINI WORLDS

Get your zoom lens ready and explore the miniature worlds around us. Zoom in and focus on small details and reveal some extraordinary miniature worlds.

Focus

- Find a minibeast habitat and zoom in.
- Focus on the detail of something familiar to everyone. See if they can guess what it is!
- Create a series of close-up nature photos. For example, you could focus on flowers or leaves.

nevis.environmental/Instagram

dans_natural_world/Instagram

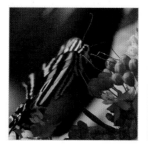
janic.tremblay/Instagram

bpa_macro/Instagram

#miniworlds #imreadyformycloseup #zoomedin #studio365challenge

STREET ART

Capture the urban landscape of a city by sharing photos of its street art. For a fun twist, have a friend interact with the art.

Focus

- Is there a certain graffiti artist in your local area? Capture their latest pieces.
- Try to capture a street artist as they work.
- Aim for a dramatic contrast photo showing the colourful art and urban landscape in one shot.

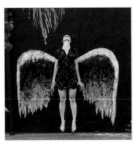

pauline.rcrt/Instagram natanaval/Instagram mr.adamrobertson/Instagram karlstephanstudio/Instagram

#streetart #graffiti #friendsandwalls #studio365challenge

♥♥♡♡♡ THROUGH MY WINDOW

Capture the view you see every day with this interesting landscape shot. Whether it's an urban view from your workplace window or a sprawling countryside landscape from your kitchen window, share it with your followers.

Focus

- Take the same photo at different times of day or year.
- Use the window as a frame and show some interior details too.
- Extend the challenge to a week, month or longer and capture views from windows wherever you go.

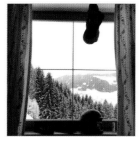

jokuko/Instagram the_spy_girl/Instagram wahinewasp/Instagram ddahan76/Instagram

#throughmywindow #roomwithaview #myview #studio365challenge

PATTERNS IN NATURE

Close-up photos of the intricate patterns of nature can be both beautiful and creative. Look for patterns in the world around you. Think about how you want to frame the image, and then snap away!

Focus

- Leave your followers guessing with super close-up photos.
- Cut open a piece of fruit, do the seeds make an interesting pattern?
- Plants and flowers often have beautiful patterning, get in close for a stunning photo.

loadcockbang/Instagram

lostinpattern /Instagram

maflorista/Instagram

lostinpattern /Instagram

#patternsinnature #repeatpattern #naturelover #studio365challenge

♥ ♥ ♥ ♡ ♡ CROSSROADS

An impactful landscape shot of a crossroads can hold many meanings. From rural footpaths to busy junctions, lure your followers into wanting to see what's down each path!

Focus

- Create a photo series – each time you come to an interesting crossroads, photograph it!
- Take your followers down the road less travelled.
- Document a journey through photos of crossroads.

randyky/Instagram

janet_chenn/Instagram

melitaivan/Instagram

shelldev24/Instagram

#crossroads #roadlesstravelled #whichway #studio365challenge

SHAPES IN CLOUDS

If you're always spotting shapes in clouds, capture the phenomenon and share with your followers!

Focus

- Ask your followers to guess what you've seen in the clouds.
- Spend a day cloud-gazing and share your favourite snaps with your followers.
- Next time you fly, take a photo above the clouds.

phibylydia/Instagram carolduncan photographer/Instagram tomokolondon/Instagram _abhinavpandey/Instagram

#cloudshapes #headintheclouds #canyouseeit #studio365challenge

STORM CHASER

♥ ♥ ♥ ♥ ♡

When the weather turns, you might want to just hibernate but the photographic opportunities can be so rewarding. Make sure to stay safe when shooting in bad weather!

Focus

- Capture a white-out during the next snowstorm. Can you build interest in an all white photo?
- If you're near the sea, shoot the whipped up waves. Don't get too close to the ocean during a storm.
- Use a slow shutter speed or long exposure to capture stunning lightning shots on your smartphone.

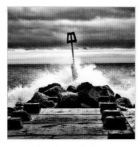

caitlindarcyphotography/Instagram

cesar.g.photography/Instagram

haukeliseter/Instagram

thejubawuki/Instagram

#stormchaser #wildweather #lightning #studio365challenge

MOONLIT WONDERS

There is something magical about the Moon on a crisp clear night and how it lights up everything around us. It can be hard to capture but filters and edits can happily bring an image closer to reality. Take time to enjoy and remember those moonlit wonders.

Focus

- Experiment with exposure and contrast when editing these pictures.
- The Moon over a wide landscape with water can be spellbinding...
- ... or look enchanting when shot through trees.

andrea_perin_98/Instagram

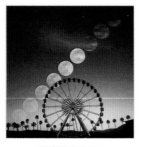

ninaslands/Instagram

solo_globetrotting/Instagram

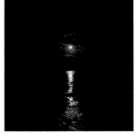

billizful/Instagram

#moonlight #fullmoon #bigmoon #studio365challenge

UNNATURAL HABITAT

Some of the most entertaining images are those depicting objects (toys for example) in unnatural habitats. There are some very clever examples out there to give you inspiration, so give it a go!

Focus

- You can make the ordinary seem quite the opposite.
- You won't need to go far to find a suitable setting.
- Your only limit is your imagination!

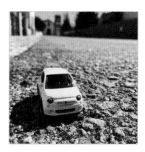

cristofem/Instagram

fathersfigures/Instagram

eviemaria/Instagram

rx78.stursa/Instagram

#unnaturalhabitat #toysoutside #outofplace #studio365challenge

KNOCK, KNOCK

♥ ♥ ♡ ♡ ♡

Ever had a thing about doors? Well if you didn't before that may change if you give this challenge a go. Begin snapping the most unusual doors that you find and you'll quickly see that any amalgamation is almost hypnotising!

Focus

- Be on the lookout at all times, and check out nooks and crannies.
- Be sure to focus on unusual knockers and colours.
- Also look out for unusually sized doors and those that lead to long-forgotten places.

1111creative/Instagram

malderamirez/Instagram

richardyoung53/Instagram

woodibabalou/Instagram

#door #doorsofinstagram #doorknockers #studio365challenge

♥♥♡♡♡ # TREESTAGRAM

Spend some time with the trees. The life givers. The oxygen suppliers. Majestic things of beauty; trees provide an endless supply of fantastic images, at any time of the year. Go give one a hug, you'll feel much better.

Focus

- Look out for isolated trees for an eerie shot.
- As well as focusing on the whole tree and its surroundings, why not zoom in...
- ... on a collection of branches or some bark.

nilawati bw/Instagram

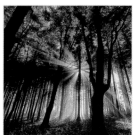
cddroom/Instagram

elamanga/Instagram

betty9570/Instagram

#treestagram #treeoflife #trees #studio365challenge

ABANDONED PLACES

Crumbling castles and abandoned architecture are just dripping with metaphors — and they make amazing photographs. Find a man-made place that's been taken over by nature and be inspired. Don't go anywhere that's not structurally sound — no photo is worth the risk!

Focus

- Take long shots of an entire area or building to show the scale of the structure...
- ... and then focus in on small details to show a personal side to the building.
- Use filters and editing to bring out a contrast in your photo to increase the drama.

babybulll/Instagram

cr_neverland/Instagram

angel_bam/Instagram

urbexcalabria/Instagram

#abandonedplaces #naturewins #lostplace #studio365challenge

 # VANISHING

Create a sense of impermanence or the great beyond with this challenge and capture something as it vanishes.

Focus

- Use some clever editing to make something disappear from your photograph.
- Look for landscapes that vanish into the distance...
- ... or photograph a landscape that will vanish in time.

mhplinda/Instagram

lou.halliwell/Instagram

denstorm/Instagram

lesliemalloyphotography/Instagram

#vanishing #disappearing #wherediditgo #studio365challenge

MIST, FOG, SMOKE

Photos of misty hazes, foggy mornings or smoky landscapes can make for very atmospheric, moody images.

Focus

- Head out in the late evening or early morning to capture a stunning landscape shrouded in mist.
- Water droplets in fog and mist make light scatter. Aim to capture some of those gorgeous light streaks.
- Where there's fire, there's smoke. Capture the tendrils of smoke from a lit match, a bonfire or even the steam in a kitchen.

nickpanagou/Instagram

makeitsnappy3/Instagram

lambob2504/Instagram

metinnurlu/Instagram

#mistfogsmoke #onefoggyday #moodymist #studio365challenge

♥ ♥ ♥ ♡ ♡ OUT OF PLACE

Look for landscapes where something isn't quite right. Whether it's an art installation or something that shouldn't be there, take a photo to share the contrast with your followers.

Focus

- If you spot something totally unexpected, take a photo!
- If there's something subtle in a landscape that shouldn't be there, see if your followers can spot it too!
- Man-made vs. nature can often look incongruous, but it makes great photography!

matthew.minion/Instagram

federicamorosini/Instagram

veevella/Instagram

thecupboardoflaughter/Instagram

#outofplace #naturevsman #unexpected #studio365challenge

FENCES

Fences are usually there to keep something in, or something out! For this challenge seek out a landscape with a fence and look for an unusual or interesting shot.

Focus

- Find a fence that isn't doing its job!
- Use the fence as a framing device for your shot.
- Focus on the detail of the fence, with the background blurred.

her vision.photo/Instagram

hankdrewphoto/Instagram

capuchenormande/Instagram

dierkesphotography/Instagram

#fences #fencedin #fencedout #studio365challenge

STRIDE BY

This is a fantastic way to either show off a landscape or to take an interesting portrait. Simply take a photo of a person striding past an interesting backdrop.

Focus

- This is a photo best taken candidly – look for interesting people and interesting locations...
- ... however you could set up this shot with a friend for maximum effect.
- Think about the placement of your subject. A long shot with the subject centrally or within the rule of thirds works best.

ali.mit/Instagram simonlarsen/Instagram jordi.not.geordie/Instagram cpplunkett/Instagram

#strideby #peoplewalkingpastwalls #urbanlandscape #studio365challenge

LIGHT OF MANY COLOURS

Few things are more pleasing than a stained glass window. It can cheer even the most gloomy of days, but when that sun is shining it casts a truly glorious sight.

Focus

- Stained glass is not just restricted to churches, or even buildings...
- ... there may be great examples elsewhere in your life so look out!
- Take images of the glass itself and contrast that with the effects on walls and floors.

leeloo_____leeloo/Instagram

treatyjewellery/Instagram

lucylimonada/Instagram

talant_v_rukah/Instagram

#stainedglass #stainedglasswindow #stainedglassart #studio365challenge

LIFE IS LIKE A BUTTERFLY

A thing of beauty, a bringer of sunshine and warmer days, butterflies extend beyond mere admiration and quite often have great symbolic meaning to many people. You're guaranteed to feel the love sharing these.

Focus

- You shouldn't have to look too far to find something butterfly-esque.
- Be on the look out when out and about...
- ... if you're really lucky you may be able to capture the real thing!

serenab_91/Instagram

jj.images/Instagram

nata4188/Instagram

christina_yoga./Instagram

#butterfly #butterflytattoo #butterflywings #studio365challenge

TRAIN SPOTTING

Once the reserve of train enthusiasts; train spotting, or more precisely train photographing can make dynamic landscape shots. Take to the railways and look out for interesting perspectives.

Focus

- Find out if any steam trains are passing through a local beauty spot for a shot that harks back to yesteryear.
- Show the industrial side of the railway with shots of cargo trains.
- Check local timetables and be prepared to wait for your perfect snap.

midwest_railfan20/Instagram vowsinparadiseweddings/Instagram wayfarer_vic/Instagram konakaboom/Instagram

#trainspotting #steamtrain #ontherailway #studio365challenge

PHONE BOX

Once an essential part of society, the pay phone has become a relic of decades past. When you spot one, make sure to capture it before it disappears!

Focus

- Look for phone boxes that have been repurposed for something else.
- Many phone boxes have been reclaimed as retro, kitsch pieces of décor. Capture them in their unnatural setting.
- Pay phones make a great subject for street photography, particularly if you see one in use.

sheema_gh/Instagram

dew1ra/Instagram

gregthomasdj/Instagram

johowell23/Instagram

#phonebox #payphone #givemeacall #studio365challenge

BIRD WATCHER

Whether you're a serious twitcher or a casual admirer of our feathered friends, there's something really thrilling about getting close enough to a bird to take it's photo.

Focus

- If you sit still long enough in a park or garden you may find the birds come to you.
- Spend a day in your local park and photograph as many bird species as you can...
- ... or head to a reserve. You may need a camera with a good zoom lens.

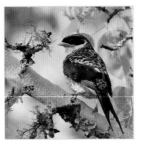

chris.packham/Instagram

these_antipodes/Instagram

lindolfosouto/Instagram

prettybirdwatcher/Instagram

#birdwatcher #twitcher #featheredfriend #studio365challenge

♥♥♥♥♡ CITYSCAPE

For this challenge you need to step away from the hustle and bustle of city life and find a viewpoint where you can see the city's skyline from a distance.

Focus

- Climb a hill, go across a bay or travel outside for the best out-of-city shots.
- Spend some time on location to get the cityscape at different times of the day.
- Focus on any iconic landmarks and place these in the centre or magical third of your shot.

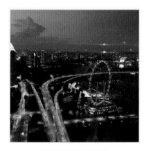
oxanaprantl/Instagram

harry1985hp/Instagram

ryan_mcaulay_photography/Instagram

tahitifred/Instagram

#cityscape #skyline #cityescape #studio365challenge

BRIGHT BUILDINGS

Every now and then you'll come across a building painted in a bright shade: it stands out against its red-bricked, dull neighbours and stops you in your tracks. Get out your camera and share the colour!

Focus

- Architectural photography is all about the angle. Look for an interesting view.
- Contrast the colour by showing the surroundings.
- Use those filters to boost that colour – unless it looks best with #nofilter

olajoaquini/Instagram

varvarenja/Instagram

latinaround/Instagram

sofia.in.wanderland/Instagram

#brightlycolouredbuilding #architecture #colourful #studio365challenge

INDUSTRIAL EVOLUTION

The industrial revolution can be seen all around us, from the modern powerhouses to the industrial endeavours of the past. Set out to create a photo series showing the role that industry plays in a certain area or culture.

Focus

- Mix-up your photos with a range of landscape and close-up photos. Both are equally evocative.
- Look for old and new and compare and contrast the buildings and techniques used.
- Explore the opposing feelings: one of the emptiness of the past; one of the vibrance and excitement of the future.

berri.e/Instagram

qubixstudios/Instagram

ibaneezyy/Instagram

picture_paz/Instagram

#industrial #industrialart #formalism #studio365challenge

SUNSHINE

Photography is all about light and what better source than the sun! Rising, setting or beating down, a beautiful day will equal beautiful shots.

Focus

- Demonstrate the journey of the sun throughout the day, by taking photos from the same spot.
- This is all about colour – either in the sun itself or from the light that shines all around.
- Take dramatic photos focusing on light and shadow.

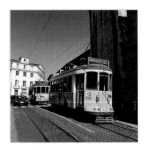
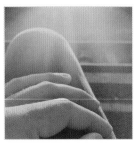
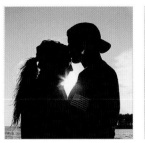
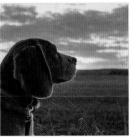

dedriiine/Instagram klimt1983/Instagram emilee.breanna.photography/Instagram ginevra_7/Instagram

#sunshine #horizon #sun #studio365challenge

 # THE COAST

Head to the coast to take some dramatic shots of the sea. Whether the weather is rough or fine, the coast has plenty to offer photographers.

Focus

- If heading to the coast in rough weather, be mindful to not get too close to the water.
- Document seaside life with a range of portraits, candid shots and landscape photographs.
- Explore the biodiversity of the coast and look out for interesting plants and animals.

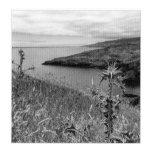

felixm1305/Instagram

philreevephotography/Instagram

sheila fidler/Instagram

s.nilde/Instagram

#thecoast #bytheseaside #iseethesea #studio365challenge

TILT-SHIFT MINIATURE ♥♥♥♡♡

This form of photography can be done using a camera, or easily added as an in-app edit on Instagram®. The selective focus used in tilt shift can often make a scene look like a miniature.

Focus

- Enhance the colours in your photograph to really make it look like a miniature.
- Experiment with using the tilt shift on a range of your photos.
- Get high above a city or town to capture a whole scene.

bogurski/Instagram

jamoo/Instagram

bogurski/Instagram

the_ballarat_life/Instagram

#tiltshift #miniatureworld #focus #studio365challenge

♥♥♡♡♡ # LOW VANTAGE POINT

Next time you're shooting a landscape get down on the ground. Lie on your belly and shoot across or upwards for an interesting vantage point.

Focus

- Use this viewpoint to capture as much of a large landscape as possible.
- Capture low-to-the-ground detail such as flowers and plants as well as the stunning backdrop.
- Architectural shots from low pointing upwards can make structures look towering.

malousinding/Instagram

imin10vewithmy0wnsins/Instagram

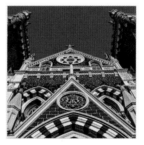
kingshukmukherjee8670/Instagram

m.a.k.photo/Instagram

#lowvantagepoint #frombelow #mouseeyeview #studio365challenge

CREEPY CRAWLIES

From butterflies and bees to slugs and spiders, the insect world is crawling with amazing bugs that just want their portraits taken. If you're squeamish about getting close to our many-legged friends, use a zoom lens!

Focus

- Look out in particular for beetles and spiders with amazing colours – just avoid anything that might bite!
- Aim to capture the rainbow in butterflies – you might even photograph something rare.
- Get as close as possible to your bug for an intimate portrait.

bradenbraden/Instagram kanyathekat/Instagram smiler_1082/Instagram thedistantsummer/Instagram

#creepycrawlies #bugslife #insect #studio365challenge

THE OLDEST

Seek out the oldest building in your locale and have a photoshoot. From old pubs to historical cottages, these old buildings are filled with character just waiting for you to photograph.

Focus

- If you can get access, snoop around the nooks and crannies.
- Look for areas of repair – you might even find some repairs are hundreds of years old!
- Find those gorgeous details that show off the fine workmanship of labourers long passed.

arti.j/Instagram

a__casanova/Instagram

reachshiks/Instagram

cascadia.wine.imports/Instagram

#oldestbuildingintown #historical #architecture #studio365challenge

DIFFERENT PERSPECTIVES

Next time you're shooting a landscape, shoot it twice (or even thrice!), each time from a different perspective. Share your photos as a series.

Focus

- Change your shooting position by walking to another viewpoint...
- ... or simply shoot from above or below for another perspective.
- Play with your depth of field, focusing on fore and background.

fit_only_with_you/Instagram

fit_only_with_you/Instagram

kren77/Instagram

kren77/Instagram

#differentperspective #anotherangle #viewpoint #studio365challenge

GLASSES REFLECTION

♥ ♥ ♥ ♥ ♡

Part selfie, part landscape shot, this dynamic photo is a fun way of showing off where you are as well as showcasing your awesome choice of eyewear.

Focus

- Use the reflective surface of your sunglasses, or reading glasses to show your location.
- Try not to get your camera in the photo.
- Experiment with close-ups and full face shots.

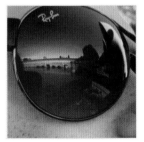
david.flshr/Instagram

migueltorres06/Instagram

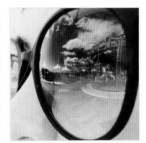
n2kki/Instagram

alyssasphotos2006/Instagram

#glassesreflection #throughmyeyes #reflective #studio365challenge

FUNGI

Wild mushrooms and fungi can be spectacular in their size, shape and colour. Next time you're out walking in the woodlands look out for some interesting specimens. Be careful not to touch and definitely don't eat them!

Focus

- Look on the forest floors for the bright red fly agaric toadstool. Watch out for gnomes!
- Fallen, soggy tree trunks are often the host of colourful fungi.
- Get up close and capture the colours and textures.

littlejennywrendolls/Instagram

thegingerbread_lady/Instagram

ptessier88/Instagram

the_mushroom_ninja/Instagram

#fungi #wildmushroom #toadstool #studio365challenge

SUBTERRANEAN

♥ ♥ ♥ ♥ ♡

Head underground for a series of photographs. From natural caves to underground stations, basement bars and even sewer systems, capture your experience of being under the earth.

Focus

- Take any opportunities you can to explore the underworld in a safe manner.
- Guided tours of cave systems are often available. See what's around locally – you might be surprised!
- Think about your lighting source – there's no (or very limited) natural lighting when you're underground.

yuval_david /Instagram

sgreenwood2016/Instagram

kunio_shachimaru/Instagram

jonjsonnurse/Instagram

#subterranean #underground #underworld #studio365challenge

OVERGROWN

There's definitely a beauty to a wild, overgrown patch of land, despite the sense of neglect. Look for overgrown areas and buildings overtaken by nature.

Focus

- Look for flowers amongst the weeds and use these as your focus.
- Overgrown doesn't mean abandoned – can you find somewhere where man and nature are living in harmony?
- If you're working on an overgrown patch, create a before and after series.

fgpdesign/Instagram

schloddde/Instagram

cribbar/Instagram

lucyspacepose/Instagram

#overgrown #wild #abandoned #studio365challenge

THE ROAD GOES ON

Create a sense of adventure and photograph a road or path stretching out ahead to the horizon.

Focus

- An empty road in a beautiful landscape is sure to stir up feelings of wanderlust in your followers.
- Play with your perspective. Try shooting from close to the ground.
- Place a subject on the road, whether it's a person or a car, to draw the eye in.

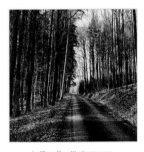

hufflepuffmuffin/Instagram

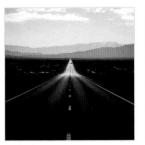

p1loto/Instagram

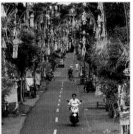

btcroads/Instagram

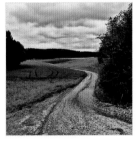

dkay.gram/Instagram

#theroadgoeson #wanderlust #stretchingout #studio365challenge

BEACH LIFE

There's something about a trip to the beach: the sand between your toes, the sea air, the freshness of the sea... and the amazing pictures to be had.

Focus

- This is the perfect opportunity for a #fromwhereistand image. Show your toes in the sand or sea.
- Stay up late for a beautiful beach sunset and experiment with your angles.
- Look out for tiny details, such as pretty patterned shells and smoothed glass.

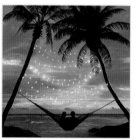

fredrikkekristoffersen/Instagram weddingz.in/Instagram ryan.crider/Instagram tourguideoahu/Instagram

#beachlife #beach #sand #studio365challenge

♥ ♥ ♥ ♡ ♡ (DON'T) LOOK DOWN

This challenge is not for the faint of heart as it requires going up high. Really high. Challenge yourself to reach a giddy height and take the most vertigo-inducing photo of your life.

Focus

- Some tall buildings have viewing platforms. Be brave and take a snap looking straight down.
- Take your friends with you too. Dare them to stand on the platform and photograph their reactions.
- It's not just looking down that can make you feel dizzy, but looking up can do so too. Plant your feet at the base of a skyscraper and take a photo looking straight up.

evokesolar/Instagram

yaelgolan100/Instagram

joesherry/Instagram

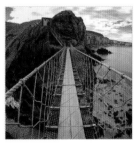
ireland_travel/Instagram

#dontlookdown #fearofheights #vertigo #studio365challenge

PARK LIFE

Playing in parks is not just for kids. Whether you're young or old, big or small, playing in the park with your friends can be a lot of fun... and it makes for great photos.

Focus

- Bring along a ball or Frisbee and start a game. Make sure to capture some action shots.
- Go for a walk around the park and look for natural photo opportunities.
- If there's a pond where you're allowed to feed the ducks, get up close for quacking shots.

galenochua/Instagram

raniafarhat88/Instagram

kristiebennett/Instagram

mumma_n_luna/Instagram

#parklife #playtime #outdoors #studio365challenge

♥♥♥♡♡

SNOW DAY

Snow has the amazing ability to make a fully-grown adult act like an excitable child, especially on snow days! Next time you find yourself in a flurry of snow, whip out your camera.

Focus

- Capture the snow falling. If it's safe, head to a local beauty spot for extra drama.
- Get out in the snow and have fun. Build a snowman, make snow angels or go sledging.
- Look for frozen details: frosted spider webs, icicles and, if you can get close enough, the patterning on snowflakes.

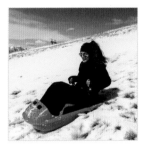

thetrendyhub/Instagram

bali the alaskanhusky/Instagram

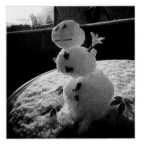

rents_da_fisherman/Instagram

juniperskyes/Instagram

#snowday #snowfun #snowflake #studio365challenge

RAINBOWS

Rainbows are rare in nature and it's even rarer to be able to capture a good photo of a rainbow. Next time the weather's right for a rainbow, grab your camera and go rainbow hunting.

Focus

- To capture a full rainbow, use a landscape shot.
- Use your filters to make those colours pop. Polarizing an image can really enhance the colour.
- Double points for a double rainbow, and triple for a triple rainbow!

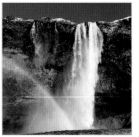
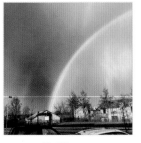

national park photography/Instagram parkbus/Instagram tlbr4un/Instagram sibischi/Instagram

#rainbow #doublerainbow #allthewayacrossthesky #studio365challenge

SERENE SCENE

Capture a sense of complete calm in a landscape photograph. For the best results, go out alone and seek a quiet location.

Focus

- Is there a place where you find your own serenity? Share this with your followers.
- Try to capture a wide shot to show the whole scene, and just how empty of people it is.
- Perhaps you find serenity in objects, such as a good book or a calming cup of tea. Share this with your fans.

capithan_/Instagram

kerisclaire04/Instagram

wigglybeads/Instagram

miiheershah/Instagram

#serenescene #completecalm #chillax #studio365challenge

CLOSED

Head out into your local town or city and seek out closed buildings. Try to find somewhere that looks completely shut up and compose your photo carefully.

Focus

- Many small towns or villages are completely closed on Sundays – head out early to catch the light.
- Look for places that have been long closed and try to capture the feeling of abandonment.
- Focus on the details, such as padlocks, shutters and signs.

chris.potter2017/Instagram

aizha.jp/Instagram

balalasko/Instagram

rioruskin/Instagram

#closed #abandoned #sleepysunday #studio365challenge

SPIDER WEBS

Providing you don't suffer from arachnophobia, close up photos of spider webs can make dramatic and interesting nature shots.

Focus

- Head out in the early morning to capture spider webs laden with dew.
- Is the resident spider in place? If you're brave enough get close for an at-home portrait.
- Use a spider web as a frame for an interesting landscape shot.

andrejbarbir/Instagram sogukmakina/Instagram scottallenhuff/Instagram ceresmulder/Instagram

#spiderweb #eightlegs #gossamerthread #studio365challenge

ART OUTSIDE

Many artists enjoy the challenge of creating sculpture and art that interacts with and reflects the landscape it's in. Go in search of some "art in the wilderness" and capture the mood of the place and piece.

Focus

- You'll be surprised at how many sculptures are hidden away in plain sight. Check under bridges and in woodlands.
- Why not shoot the sculpture from a variety of angles to get the right composition?
- Explore urban settings, too. Street art can often reach the same level as high art.

ulia johnston/Instagram

jillysam/Instagram

reemo_757/Instagram

capecodbeth/Instagram

#artoutside #woodlandsculpture #trollbridge #studio365challenge

ANCIENT STRUCTURES

Seek out the structures built by our ancestors long passed with your camera and share our shared history with your followers.

Focus

- Standing stones are shrouded in mystery. Capture a sense of ancient mythology in your photo.
- Ruins of buildings can often tell a lot about the people that lived there; look for details and clues.
- Many ancient places are tourist attractions. Try to find long-forgotten places too.

chaz_sands/Instagram i_stayfit/Instagram marcomarkovich/Instagram loicsmn/Instagram

#ancientstructures #mythology #ruins #studio365challenge

SUBURBIA

♥ ♥ ♥ ♡ ♡

It's a place categorised by architecture, gardens and similarity. You may not live there but you will have a well-formed image of what the suburbs mean to you.

Focus

- Look for patterns and symmetry.
- Highlight the functional versus nature, where possible.
- Make the ordinary look extraordinary.

tiffanydonahue/Instagram

clemence taralevich/Instagram

alifemostordinary/Instagram

michaelraun/Instagram

#suburbia　　　#hiddengems　　　#manmade　　　#studio365challenge

TINY PLANETS

The technical term is stereographic projection and its results are fantastic. You'll need some photo editing software, but it's totally worth the effort.

Focus

- Take a panorama shot, and then look up the step-by-step for creating a Tiny Planet photo.
- Make sure the 'ground' and the 'sky' elements are plain in colour, as they will be distorted.
- Have fun experimenting with different 'landscapes'.

idceh84/Instagram my360pix/Instagram jonsimo/Instagram benclaremont/Instagram

#tinyplanet #lifein360 #spherical #studio365challenge

UNDER THE BRIDGE

It's the place where trolls are rumoured to live, but be brave and head beneath a bridge to capture a different perspective.

Focus

- Bridges in cities often hide secrets beneath. If you can, head below to see what you find.
- Every bridge is a feat of engineering, focus on the structure and details.
- Bridges in nature often have an idealistic aesthetic about them – try to capture this for your followers.

lakwatsera_at_heart/Instagram

le_genadijus/Instagram

patrick_delanty/Instagram

senaozgoren/Instagram

#underthebridge #trollbridge #citybridge #studio365challenge

♥♥♥♡♡ LITTER BUG

It's so sad to see natural beauty spots littered with rubbish that could so easily have been thrown away responsibly. Create a social commentary series and photograph the contrast between nature and trash.

Focus

- Juxtapose the dirty trash against the beauty of nature by upping your contrasts.
- Organise a litter-pick in a local area and photograph your progress.
- If you can safely dispose of the rubbish, do your bit and help tidy up – you could even photo the litter-free space.

littachic/Instagram

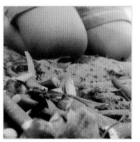
littachic/Instagram

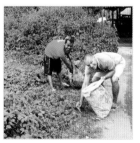
seamadeproducts/Instagram

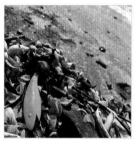
cassandra.oceana/Instagram

#litterbug #litterinnature #cleanitup #studio365challenge

LONG EXPOSURE IN NATURE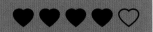

With something to steady your smartphone and the help of a low shutter speed app, it's possible to take those dream-like long exposure photos that get all those likes.

Focus

- Moving water is a great place to start and will give you a blurry, ethereal image.
- Cloud movement, too, is a great long exposure capture. Focus on the skies.
- Experiment with different shutter speeds and locations to get used to this photo method.

fromabovephotography/Instagram cesar.vasquez.jr/Instagram jiprockphotography/Instagram marco.carotenuto/Instagram

#longexposure #movingnature #flowingwater #studio365challenge

NEVER VISITED

Go for a walk around your local area and take a path or road you've never taken. Visit an area you've never been before and capture what you see.

Focus

- Pop into the grounds of a church that you walk past every day.
- Walk one road further than you usually do and see what you can find.
- Wander and see where your feet take you. Just make sure you can remember how to get back!

chezebel/Instagram

dgwgo/Instagram

edsonvitrinefut/Instagram

michelle2261/Instagram

#nevervisited #anewview #wandering #studio365challenge

URBAN NATURE

Nature always finds a way through, even in the most urban of areas. Look for interesting contrasts and interactions between an urban setting and the power of nature.

Focus

- Look out for bright pops of natural colour against the mundane grey of an urban landscape.
- Make sure you capture both natural and urban details in your shot.
- Alternatively, look for signs of urban life in a natural setting.

furniture_makers/Instagram

ckbevers/Instagram

dcherrickphotog/Instagram

mpbnyc/Instagram

#urbannature #naturevscity #naturewins #studio365challenge

Share with us!

CREDITS

Front cover (from top left clockwise): jerm_cohen/Instagram; cocochanelli/Instagram; _da_n_i_/Instagram; vickiee_yo/Instagram; jasperthegoldenboy/Instagram; benclaremont/Instagram; natanaval/Instagram; pruetully/Instagram; thegirltravels/Instagram; d_girl77/Instagram; ninaslands/Instagram; bzoratto2/Instagram .

Back cover (from top left clockwise): sayhellotoamerica/Instagram; rachelabbie/Instagram; tamnoonf/Instagram; tommasocarraro/Instagram; edihartonoliem/Instagram; nemerise/Instagram.

Inside front page (from top left to bottom right): nao_k_/Instagram; steffi__ha/Instagram; labradoroftheday/Instagram; camilladallerup/Instagram; chinpua/Instagram; elenaarielle/Instagram;. trucosparadecorar/Instagram; ryanlongnecker/Instagram; princess_tevy/Instagram; den.sa90/Instagram; oldbluebbq/Instagram; _mr_stormtrooper/Instagram; crown.brew/Instagram; casey_maryellen/Instagram; cristofem/Instagram; jj.images/Instagram.

Inside back page (from top left to bottom right): ferynlouise/Instagram; vaitsou_eleni/Instagram; marcotamby/Instagram; shopthebluehydrangea/Instagram; one_lucky_mama/Instagram; lostinpattern_/Instagram; simonchaytor/Instagram; shivarosedesigns/Instagram; galenochua/Instagram; 365_today/Instagram; johanna_stayyourself/Instagram; timoment/Instagram; pcbilbondo/Instagram; wallaceknows28/Instagram; aalex.wills/Instagram; joy_crack/Instagram.